LEGENDARY

— OF —

HUNTSVILLE
ALABAMA

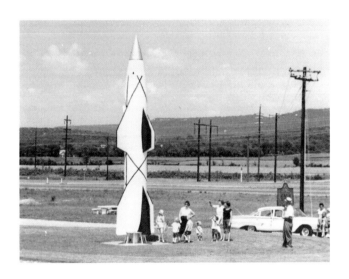

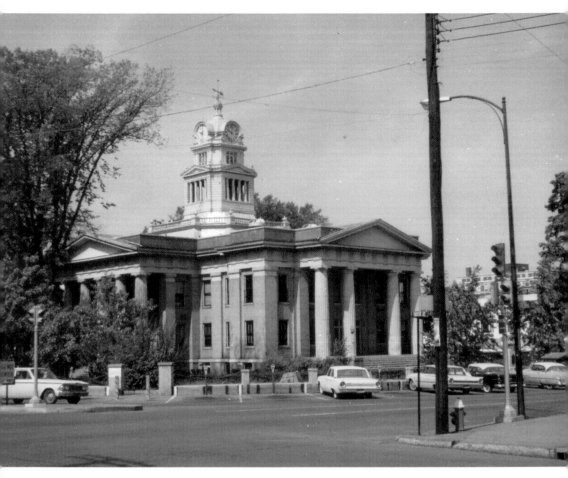

Madison County Courthouse
The third of four courthouses, this building (1914–1964) was a remodel of a Parthenon-style structure that George Steele designed in the late 1830s. The third courthouse was replaced by the contemporary structure that stands on the square today. (Courtesy of the Huntsville–Madison County Public Library Archives.)

Page 1: Hermes Research Test Missile
Pictured here in 1956 at the old Huntsville Airport on Airport Road and South Memorial Parkway, the Hermes missile was one of the first rocket symbols that welcomed visitors and future residents alike to "The Rocket City." (Courtesy of the Huntsville–Madison County Public Library Archives.)

LEGENDARY LOCALS
—— OF ——

HUNTSVILLE
ALABAMA

LESLIE NICOLE THOMAS

Legendary Locals is an imprint of Arcadia Publishing
Charleston, South Carolina

Printed in the United States of America

Library of Congress Control Number: 2014956119

For all general information, please contact Arcadia Publishing:
Telephone 843-853-2070
Fax 843-853-0044
E-mail sales@arcadiapublishing.com
For customer service and orders:
Toll-Free 1-888-313-2665

Visit us on the Internet at www.arcadiapublishing.com

Dedication
For the people of Huntsville, both past and present, who have for any amount of time made this place their home, who have made its thriving their passion, and who have made its preservation their life's work.

On the Front Cover: Clockwise from top left:
Wernher von Braun, rocket scientist (courtesy of the Huntsville–Madison County Public Library Archives; see page 54), Bill Holbrook, comic strip artist (courtesy of the Huntsville–Madison County Public Library Archives; see page 94), Susanna Phillips, opera singer (courtesy of Susanna Phillips; see page 116), Huntsville Suffragettes (courtesy of the Huntsville–Madison County Public Library Archives; see page 19), Maria Howard Weeden, artist and poet (courtesy of the Huntsville–Madison County Public Library Archives; see page 24), John Stallworth, NFL receiver (courtesy of the Huntsville–Madison County Public Library Archives; see page 89), Anne Bradshaw Clopton, artist (courtesy of the Huntsville–Madison County Public Library Archives; see page 38), Dulcina DeBerry, librarian (courtesy of the Huntsville–Madison County Public Library Archives; see page 42), Margaret Anne Goldsmith, preservationist and historian (courtesy of the Huntsville–Madison County Public Library Archives; see page 125).

On the Back Cover: From left to right:
Harvie Jones, architect and preservationist (courtesy of the Huntsville–Madison County Public Library Archives; see page 85), Frances Cabannis Roberts, educator (courtesy of the Huntsville–Madison County Public Library Archives; see page 60).

CONTENTS

Acknowledgments 6

Introduction 7

CHAPTER ONE The Land: Founding and Flourishing 9

CHAPTER TWO The Industry: 31
 Mills and Prosperity through the Depression

CHAPTER THREE The Stars, the Moon, and the National Terrain: 45
 Redstone Arsenal, NASA, and Civil Rights

CHAPTER FOUR The Present Future: Technology and the Arts 69

Index 127

ACKNOWLEDGMENTS

Without the unparalleled devotion, organization, and countless hours of time and thoughtful focus and expertise of local historians and archivists, assembling a book of this scope would not be possible. Many thanks to archivist Susanna Leberman of the Huntsville–Madison County Public Library for her knowledge, patience, and kindness in brainstorming from the very beginning and for following through to the end as a content editor, as well as for her direction in locating photographs among a plethora of manila folders and metal filing cabinets in the archive room of the library. Many thanks also to Thomas Hutchens, also of the Huntsville–Madison County Public Library, for his meticulous research of obituary indexes and thorough editing, and to Deane and Carol Dayton of the wonderful and evolving online Huntsville History Collection database of innumerous scanned documents and endless resources about the individuals who have made the city of Huntsville what it is today and what it continues to become.

It is a huge gift for someone to give you part of their story. It has been an honor to meet so many of the incredible individuals in this book, and I appreciate so much their kindness and trust in sharing their own biographies or the biographies of their loved ones with me. It is my sincere intent and fundamental hope that I have represented you and your contributions accurately and well. Many thanks to Scott McLain, Doris McHugh, Jim Hudson, Harvey Cotten, Ron Harris, Mike Latty, Bobby Eaton, Jan Davis, Loretta Spencer, Gloria Batts, Liz Hurley, Margaret Hoelzer, David Harwell, Susanna Phillips, Robert Kennedy, Debra Jenkins, Tommy Battle, Margaret Anne Goldsmith, David Herriott, Linda Smith, and Derek Simpson.

Thanks also to those who made the connections to the people whose stories I sought to convey and to the corresponding documents and photographs: Cassie Barber, Lucy Brown, Julia Butts, Anne Coleman, Mitzi Connell, Jackie Eldridge, Bob Gathany, Carol Lambdin, Patty Tomlinson Long, Craig Maples, Steve Maples, Joe Martin, Pat Mirandy, Karen Mockensturm, Lauren Mosley, Mary Nicely, Nancy Noblitt, Karen Petersen, Kelly Schrimsher, Linda Soulé, Ed Stewart, Stephanie Timberlake, Terrence Ward, and Lynne Williams.

To my editor, Erin Vosgien, many thanks for fielding my questions and concerns, for checking photograph upon photograph, and for checking in right when I needed it most.

And to my husband, Shaun, eternal and abundant thanks for your endless support and cheerleading, for patiently and intently listening to me read the stories of these individuals as I wrote them, and for giving up the kitchen table, so I could have a workspace, for the better part of a year.

INTRODUCTION

Nestled in the Tennessee Valley, in the drainage basin of the Tennessee River and surrounded by mountains associated with the Cumberland Plateau, Huntsville boasts a yearly canvas of seasonal color and breathtaking natural beauty as varied as the individuals who made and continue to make it the shining star of North Alabama. Huntsville, the county seat of Madison, is constantly named one of the most desirable cities in which to live, to do business, and to raise a family.

From its beginnings as a contested land between two Indian tribes to the pioneering spirit of its settlers, through siege during the Civil War to its steady evenness, and even growth, during the Great Depression, the spirit of Huntsvillians has never waned. Following a period during which cotton was king and the city had a number of functioning, prosperous mills, Huntsville landed on the national map when the federal government located a munitions plant here. Comprising over 38,000 acres, Redstone Arsenal today employees over 35,000 individuals and is home to NASA's Marshall Space Flight Center, the US Missile Defense Agency, the US Army Aviation and Missile Command, and the headquarters of the US Army Materiel Command, among other organizations.

Huntsville is home to a number of technological endeavors that have made an impact on the national and international scene, including Sanmina Defense and Aerospace, Adtran, and HudsonAlpha Institute for Biotechnology.

But the Rocket City is not one-sidedly technological. Its locals have always valued both education and the arts, and it boasts several highly regarded institutions of higher learning, as well as countless arts organizations, including an arts council, a symphony, and a ballet company. Two of the mills have been transformed—one into a performing arts center and the other into an arts and entertainment center, the largest of its kind in the Southeast.

Throughout its evolution, Huntsville remains a town of constant innovation, transition, and transformation, while maintaining its grace and friendliness with a touch of charm and a dash of pride as modest as the house John Hunt built under a bluff near the Big Spring in 1805.

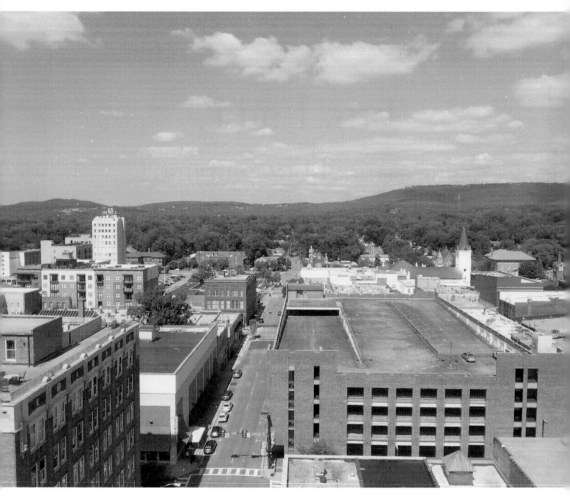

Downtown Huntsville
Downtown Huntsville is seen in this south-facing photograph taken from the top of the Russel Erskine Hotel. In the background is Monte Sano Mountain. (Photograph by the author.)

CHAPTER ONE

The Land

Founding and Flourishing

At the beginning, what is now Madison County was the subject of rivalry between the Chickasaw and Cherokee tribes. The federal government eventually became involved, forcing the Indians to relinquish their rights to "The Great Bend" of the Tennessee River. Anglo settlers began to arrive, among them John Hunt, who had previously settled lands to the north in Tennessee, and who built his home near the Big Spring.

In the years that followed, those first settlers farmed cotton, connecting Huntsville to the rest of the nation by utilizing the Tennessee Valley waterways. Wealthy planters and speculators on the cotton economy built sprawling mansions in Huntsville. Architects like George Steele began to make statements on the architectural terrain of the town while simultaneously employing individuals in construction and supporting local businesses in pursuit of supplies. Statesmen from other parts of the country, such as Clement Comer Clay and William Wyatt Bibb, began to move to Huntsville and go about the work of establishing a government. Alabama was entered into the Union in 1819.

The infrastructure flourished—Dr. Thomas Fearn and his brother developed the Huntsville Water Works, using hydraulics to provide water to the city. Additionally, they built the Indian Creek Canal, the first canal in Alabama, to transport cotton from Huntsville to the Tennessee River. Rev. A.B. Jones and the Methodist Episcopal Church founded the Huntsville Female College. William Hooper Councill founded Alabama A&M University.

During the Civil War, Huntsville became a target for Union troops, who sought to seize the depot, home to the Memphis & Charleston Railroad—a lifeline for the Confederacy. Union troops successfully occupied Huntsville by the summer of 1863, though many did not make it through the winter. Mary Jane Chadick chronicled the experience in her diaries until the war ended in 1865.

After the war, artists such as Howard Weeden began to bring national attention to Huntsville. Jersey cow Lily Flagg won records for yearly butter production. United Charities opened the Huntsville Infirmary in 1895. Entrepreneurs like Robert and Daniel Harrison and Isaac Schiffman opened businesses on the square, and Dunnavant's Department Store opened downtown. The city finally had its own newspaper, the *Huntsville Daily Times*.

Students of the Huntsville Female Seminary
The Huntsville Female Seminary opened in 1831, replacing the Huntsville Female Academy. Architect George Steele designed a facade for it in the mid-1850s. The seminary closed in 1862, and the building was used as a smallpox hospital during the Civil War. (Courtesy of the Huntsville–Madison County Public Library.)

John Hunt's Cabin
John Hunt, an experienced explorer and pioneer, had settled lands in Tennessee prior to finding himself in present-day Huntsville. Hunt built his house under a bluff in 1805 near what is now known as Big Spring. He asserted his rights to the land through squatters' rights and lived there until 1809, but lost the land because he had not paid the registration fee for it. By that time, the settlement was the obvious and ideal choice for the county seat. The town was incorporated two years later, on November 25, 1811. (Courtesy of the Huntsville–Madison County Public Library Archives.)

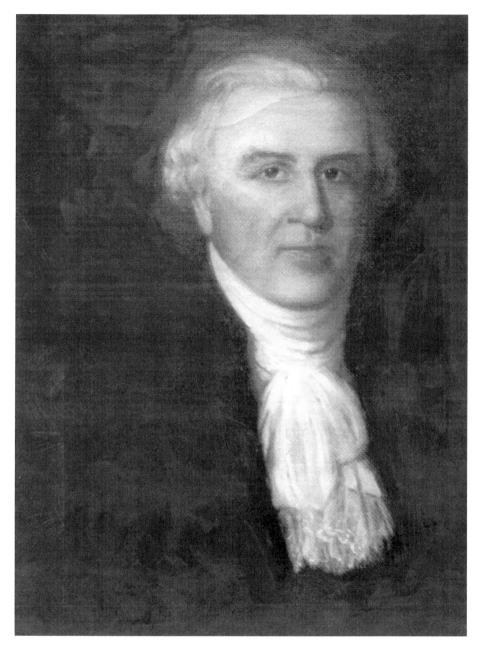

Leroy Pope

A wealthy planter from Petersburg, Georgia, Leroy Pope (1764–1845) is known as "the Father of Huntsville." In 1810, he purchased 160 acres of land settled by John Hunt for $23.50 per acre; it was on this land that the plan for Huntsville was eventually laid. Pope suggested the settlement be called Twickenham, after Alexander Pope's English home. Leroy Pope later handed over his land to the city, which was incorporated in 1811 as Huntsville.

Pope built his own home in 1825 on a bluff known as Echols Hill. He marveled that he could look out from his mansion to see the temporary capital of the state and thriving town he had helped create. (Courtesy of the Huntsville–Madison County Public Library Archives.)

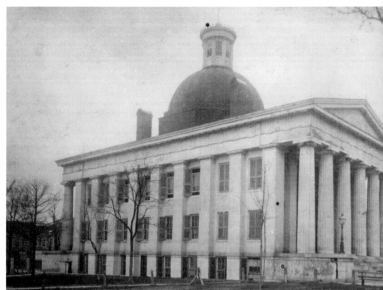

George Gilliam Steele

Because of bricks stamped with his name, it is clear that land speculator George Steele (1798–1855) was in Huntsville by 1822 at the latest, and likely as early as 1818. The Virginia native married Eliza Ann Weaver in 1823 and bought 10 acres of land from Leroy Pope in 1824, in an area roughly bordered by Clinton, Randolph, Lincoln, and Calhoun Streets in downtown.

With the labor of his 74 slaves, many of whom were skilled bricklayers, masons, and stonecutters, Steele explored and executed his passion for architecture. Steele attended architectural lectures in New York City and most likely learned the art of architecture as an apprentice. He resorted often to the use of builder's pattern books and embraced the Federal style just as it was falling out of favor in other parts of the country.

Steele later turned to the Classical Revival style, evident in his work as the leading architect of the second Madison County Courthouse (1836, pictured above right) and in his design of the State Bank of Alabama (1835) on the west side of the square. Both buildings have a signature temple form, as does his remodel of Dr. Thomas Fearn's home on Franklin Street in downtown Huntsville. Steele's elegant and simple style permeated other landmarks as well, including the Huntsville Female College (early 1850s), the Huntsville Female Seminary (1831), the Cumberland Presbyterian Church (1845), and the Leroy Pope mansion (1815). Of these structures, only the Pope mansion still stands today.

Steele employed many local bricklayers, painters, masons, and carpenters, and turned to local businesses for supplies, providing numerous local jobs. Steele Street, named after him, remains one of the most architecturally interesting streets in Huntsville, a perfect microcosm of architectural design and preservation in stunning tribute to its namesake. (Both, courtesy of the Huntsville–Madison County Public Library Archives.)

Thomas Bibb

Born in Virginia, Bibb (1784–1839) served on the Committee of 15 as one of the 44 delegates to the Alabama Constitutional Convention held in Huntsville, which drafted the details for the first constitution of the state. As part of the Florence-Cypress Land Company, he and four other trustees joined in 1818 to establish the town of Triana, the second town incorporated in Madison County. Called by James Record "a dream come true," Triana was located at the mouth of Indian Creek, situated perfectly to transfer large quantities of cotton and other goods from the Tennessee River to the rest of the country.

Along with 450 others, many of whom, like Bibb, lived in other places, he signed the Simms Settlement petition to request the US government not remove Anglo Americans from parcels they had settled on Chickasaw Indian land in what is present-day Giles County, Tennessee. Bibb built Belle Manor (presently known as Belle Mina) in Limestone County. A replica of the Georgian-style plantation can be seen on Williams Avenue in downtown Huntsville. Bibb was president of the Alabama state senate as well as the second governor of the state, a position he assumed following the death of his brother, William Wyatt Bibb.

Though Thomas Bibb died in New Orleans, he was reinterred 20 years after his death at Maple Hill Cemetery, where four other Alabama governors are buried. It is rumored that Bibb's body was preserved in a barrel of whiskey to transport him to his final resting place. (Courtesy of the Huntsville–Madison County Public Library Archives.)

William Wyatt Bibb
The eldest of eight children, William Bibb (1781–1820) studied at William and Mary College prior to receiving a medical degree from the University of Pennsylvania. He then moved to Georgia, where he served in the state senate. In 1817, he was appointed governor of the territory of Alabama and, in 1819, worked tirelessly to secure Cahaba as its capital. Bibb also worked to set up the fundamental aspects of the government of this new state, which entered the Union in 1819. Bibb was married to Mary Freeman.

Although he suffered from tuberculosis and other ailments, Bibb died not because of his poor health, but from injuries sustained after being thrown from a horse that had been surprised by a clap of thunder during a storm. Bibb's brother Thomas finished his term as governor. (Courtesy of the Huntsville–Madison County Public Library Archives.)

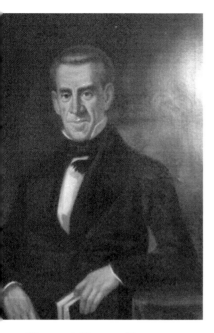
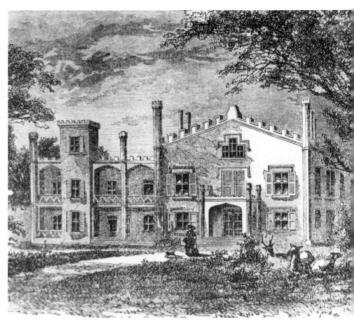

Clement Comer Clay

Born in Halifax County, Virginia, Clement Clay spent his childhood in Tennessee, received his law degree from East Tennessee College, and moved to Huntsville in 1811 after being admitted to the bar in 1809. He chaired the Committee of 15, representing Madison County at the Constitutional Convention in 1819.

Clay (1789–1866) had a robust political career, serving on the state supreme court from 1820 to 1823 as its first chief justice. Described by some as the most popular statesman of the period, he continued his political career as a member of the Alabama legislature (1827), a member of the US Congress (1829), as the eighth governor of Alabama (1835), and a member of the US Senate (1837). His only break from politics was self-imposed and came between 1823 and 1827, following a duel in which he allegedly shot his opponent in the leg.

Clay spent a fair amount of his political career handling the Creek Indian War of 1836, a fracas between the Indians and white settlers over land. His office eventually was the site for one of Huntsville's post offices and, later, of the US State Surveyors Office, which mapped vast areas of Indian territory in North Alabama prior to their sale by the federal government.

Clay's son John Withers Clay was the editor of *The Huntsville Democrat* and lived in a home on Eustis Avenue originally built for the steward of the Huntsville Female Seminary (above right). Clay is one of five Alabama governors buried in Maple Hill Cemetery. (Both, courtesy of the Huntsville–Madison County Public Library Archives.)

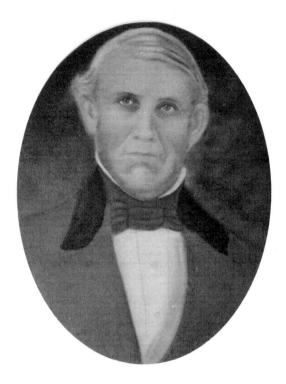

Thomas Fearn
Graduate of the Royal College of Surgeons and of St. Thomas' in Paris, and with honorary degrees from Rutgers and Transylvania Universities, Dr. Thomas Fearn (1789–1863) acquired a wonderful reputation as a doctor and as a public servant in his community.

Dr. Fearn experimented successfully with the medicinal use of quinine, making it from the bark of a tree and using it to reduce fever caused by typhoid. He is sometimes credited with the naming of Monte Sano, following his construction of a cabin on the mountain for the purpose of housing an ill child.

In addition to his numerous achievements as a medical doctor, Dr. Fearn served the public in many other ways, including as an active member of the First Presbyterian Church, a part of the Committee of Vigilance, part of the first Confederate Congress, and a leader in the abolitionist movement.

In 1835, he and his brother George spent $2,530.30 to acquire Huntsville Water Works and went on to build Alabama's first, and the nation's second, waterworks system, supplying the town of Huntsville with water from the Big Spring by way of hydraulic machinery. Along with Leroy Pope, Fearn was one of the commissioners assigned to incorporate the Indian Creek Navigation Company, which headed the Indian Creek Canal project. This first canal in Alabama, the Indian Creek Canal (now the Big Spring), was begun in 1820 and completed in 1831, due in large part to the efforts of Fearn, who was known as the president and leading spirit of the canal enterprise; Fearn's Canal, as it came to be called, was declared the first navigable canal in the western country in 1827.

After the canal opened, the Fearns began opening sawmills and gristmills on their newly acquired timberlands and announced in 1835 that they were starting the Huntsville Canal Company. By that point, however, there was little public interest in non-mechanized timber production, and the company did not move forward successfully.

Fearn served three terms in the Alabama House of Representatives, served on the board of planters and on the board of Merchants Bank, and collaborated with Clement Comer Clay, eighth governor of Alabama, to promote a railroad connecting Memphis, Tuscumbia, Huntsville, and Rome, Georgia. He and his brother helped develop Viduta, incorporated in 1833 on Monte Sano Mountain. Dr. Fearn was the father of seven daughters and was predeceased by his wife by 21 years. (Courtesy of the Huntsville–Madison County Public Library Archives.)

A.B. Jones

In 1851, Rev. A.B. Jones (d. 1924) and the Methodist Episcopal Church organized and founded the Huntsville Female College. Housed on Randolph Street in a building designed by George Steele, the college was a premier institution of female education for students in the primary grades through college level. It offered a wide variety of courses, including English, Latin, German, music, drawing, and painting. Huntsville Female College's goal was to "secure the symmetrical development of body, mind, and soul."

The college was destroyed by fire in January 1895. Jones relocated to Gadsden, Alabama, to open another institution of learning, Jones College for Young Ladies, which he opened in the former Bellevue Hotel. Below, former students of Huntsville Female College gather for a reunion. (Both, courtesy of the Huntsville–Madison County Public Library Archives.)

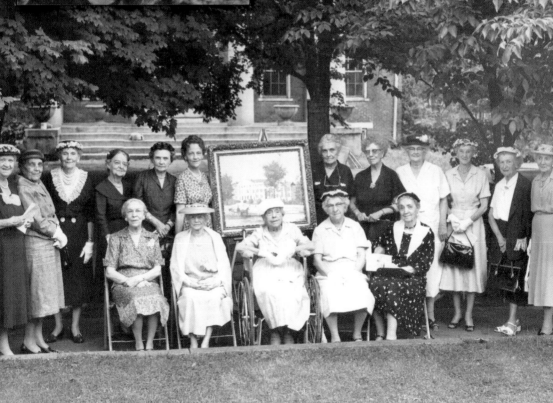

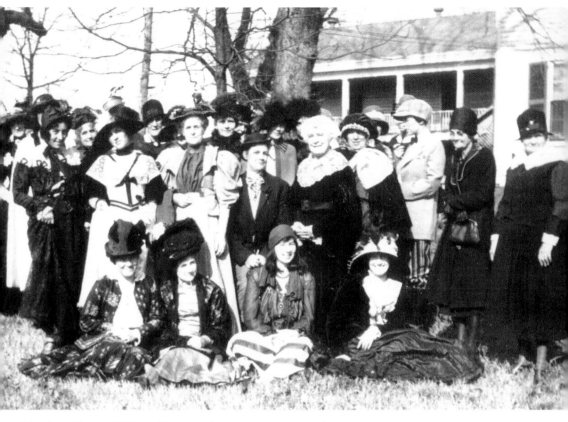

Virginia Tunstall Clay-Clopton (ABOVE AND OPPOSITE PAGE)
Known to many as the "Belle of Washington," Virginia Clay Clopton (1825–1915) spent the first part of her life a bit less glamorously than the place to which her socialite status eventually took her. Born in Nash County, North Carolina, she passed much of her childhood in Tuscaloosa, Alabama, and her years as a young lady in Nashville, Tennessee. She graduated from the Nashville Female Academy in 1840 and married Clement Claiborne Clay shortly thereafter and moved to Huntsville. When Clay was elected to the US Senate in 1853, the Clays moved to Washington, where Virginia hobnobbed with a number of socialites, including Jefferson and Varina Davis.

Upon Alabama's secession from the Union in 1861, Clay resigned his Senate seat to join the Confederate legislature. Accordingly, Virginia moved her socializing to Richmond, Virginia, remaining close friends with Varina Davis—a friendship that proved a good support system in 1865, when both women's husbands were arrested for conspiracy to assassinate President Lincoln. In spite of Virginia's numerous letters and written appeals to beg for the release of her husband, Clay remained a prisoner in Fort Monroe, Virginia, until he was released by President Johnson in 1866 and returned to Huntsville. After Clay's death 16 years later, Virginia eventually remarried.

Following the death of her second husband, Virginia wrote an account of her years in Washington as a socialite and southern belle, with particular attention to the details surrounding the South's evacuation from Washington following Alabama's secession from the Union. Her book, *A Belle of the Fifties: Memoirs of Mrs. Clay, of Alabama, Covering Social and Political Life in Washington and the South 1853–1866*, offers a picaresque, poetic, and erudite account of Virginia's life, beginning with her girlhood in Tuscaloosa and continuing through her first husband's release from Fort Monroe. Doubleday published the book in 1904, by which point Virginia had become actively involved in the suffragist movement, a cause for which she fought until her death in 1915. Pictured above are Huntsville suffragettes. (Both, courtesy of the Huntsville–Madison County Public Library Archives.)

Sally Carter

Just three weeks shy of her 16th birthday, Sally Carter (1821–1837) was visiting her sister at the Cedarhurst plantation in Huntsville when she fell ill and died; she had been staying on the second floor of the home. Many years later, a boy from South Alabama was visiting the home, sleeping on a cot outside of Carter's former bedroom. He had a dream about her one night during a thunderstorm in which Carter informed him that her tombstone, just outside the home, had been toppled by the storm. When he went out the next morning to check, the stone had indeed fallen.

Carter's grave on the Cedarhurst site was visited by many people curious about her fate and subsequent lingering presence, and unfortunately, by vandals as well. When the land was developed into a gated community in the early 1980s, her grave was moved to Maple Hill Cemetery, though her bedroom remained preserved in the home, which is now the community's clubhouse. Residents still report strange happenings around the room—doors opening and closing, and sometimes, the sound of a girl's laughter. In this photograph, Leslie Kilgore portrays Sally Carter at her grave during the 2013 Cemetery Stroll sponsored by the Huntsville Pilgrimage Association. (Photograph by the author.)

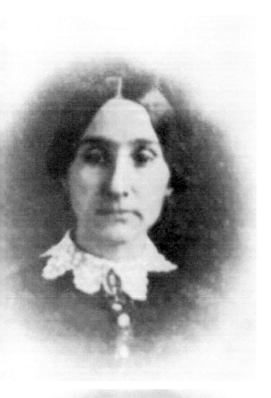

Mary Jane Chadick
The wife of a Presbyterian minister, Mary Jane Chadick (c. 1820–1867) kept a diary and detailed account of the Union occupation of Huntsville during the Civil War between 1862 and 1865. Chadick recorded the Union's successful and quick takeover of the depot, Huntsville's lifeline to such cities as Charleston and Memphis. Chadick recorded such details as Huntsville's brief reprieve from Union occupancy between 1862 and the summer of 1863, when 5,000 Federal troops occupied the city; and the winter of 1864, when harsh conditions, in combination with a smallpox outbreak and an explosion at the depot, killed off many of the troops. Chadick ceased her recordings shortly after Robert E. Lee's surrender in April 1865. (Courtesy of the Huntsville–Madison County Public Library Archives.)

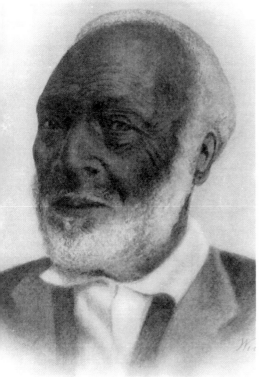

Bartley Harris
In 1820, William Harris established the African Baptist Church, the oldest Primitive Baptist church in the state of Alabama. Because slaves did not have property rights, the congregation met in the Old Georgia Graveyard, a slave cemetery near the intersection of Governors Drive and Madison Street, where Huntsville Hospital is now located. The congregation eventually built a church in the graveyard, which was burned down during the Union occupation of Huntsville in the Civil War. In 1972, Ulysses S. Grant granted money to rebuild the church in a nearby location, and the church was renamed the Saint Bartley Primitive Baptist Church, after the second pastor of the church, Bartley Harris (pictured). During his time as pastor, Harris baptized over 3,000 people in the Big Spring. He is buried in Maple Hill Cemetery. (Courtesy of the Huntsville–Madison County Public Library Archives.)

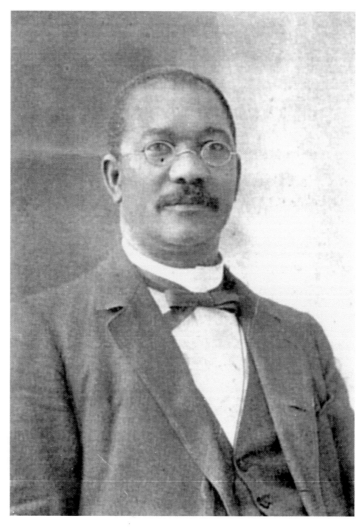

William Hooper Councill

An ex-slave who arrived in Alabama in 1857, William Councill (1848–1909) helped to establish and found Alabama A&M University. Known then as the Colored Normal School at Huntsville, the school opened in May 1875 with 61 students and two teachers in a rented building on Clinton Street. Councill served as the school's first president.

Under the directive of a bill in the Alabama state legislature in 1873 to establish "a state normal school and university for the education of the colored teachers and students," the school, receiving state funding through the land-grant process, was required to defer to the state. A&M's curriculum, under the direction of Councill, focused on industrial education, and quite successfully so. The school quickly received more state funds and eventually changed its name to the State Normal and Industrial School at Huntsville. The school continued to excel and received more money under the 1890 Morrill Act in order to support programs in engineering and agriculture. It changed its name again to the State Agricultural and Mechanical College for Negroes and moved to a larger campus, its current location in Normal, Alabama, in 1891. By 1948, the school was called Alabama Agricultural and Mechanical College and was fully accredited by the Southern Association of Colleges and Secondary Schools by 1963. By 1969, it became Alabama A&M University, as it is known today. It offers graduate programs and enrolls over 5,300 students. (Courtesy of the Huntsville–Madison County Public Library Archives.)

Leroy Pope Walker
Although Walker's career was bookended by his law practice, it is perhaps the time in between that allowed him to leave his mark on history. Born in Huntsville, Walker (1817–1884) attended the University of Alabama in Tuscaloosa and went on to get his law degree from the University of Virginia in Charlottesville. He served in the Alabama House of Representatives, including time as speaker. During the 1860 Democratic National Convention, he chaired the Alabama delegation to that convention. A secessionist, Walker was the first Confederate secretary of war and gave the orders to fire on Fort Sumter, the event that officially began the Civil War. During wartime, Walker served as a brigadier general in the Confederate army and as a military court judge. After the war, he resumed his career in law, defending such notables as Frank James, the brother of outlaw Jesse James. He presided as president of the Alabama State Constitutional Convention in 1875. Walker is buried in Maple Hill Cemetery. (Courtesy of the Huntsville–Madison County Public Library Archives.)

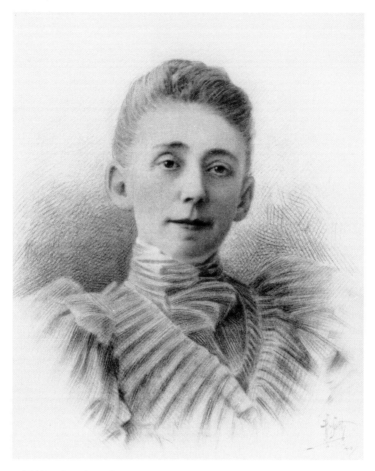

Maria Howard Weeden (ABOVE)

Artist and poet Maria Howard Weeden (1846–1905), known eventually as Howard, grew up in Huntsville and attended the Huntsville Female Seminary. Her father died when she was only a baby. Her mother recognized Howard's artistic talent at a young age and acquired for her private art lessons. The development of this talent proved quite useful in later years, when Howard was able to paint notecards, mementos, and other trinkets to sell, as well as offer her own art classes when the family experienced financial hardship.

During the Civil War, Union troops occupied the Weeden family home, and they were forced to vacate to Tuskegee, where Weeden attended the Tuskegee Methodist Female College. While there, she made the acquaintance of George Price, whose daughter Elizabeth became a close friend and advocate of Weeden's. Elizabeth displayed Weeden's works in her Nashville music studio and also carried several of her portraits to Germany to display in a gallery there.

Weeden became most known for portraits of the freed people who had come to have such an influence on her life and on her upbringing. Her works appeared in several books in her later years, including *Shadows on the Wall*, published by a small press in Boston. Other books followed, and Weeden began to write her own poems to tell the stories of the people whose images she so expertly and realistically portrayed. One of her paintings is on the opposite page.

Weeden, who wrote many articles for the *Christian Observer* newspaper under the pseudonym Flake White, died in her home, the same one in which she was born, in April 1862. She is buried in Maple Hill Cemetery. (Above, courtesy of the Huntsville–Madison County Public Library Archives; opposite, courtesy of the Weeden House Museum and Garden.)

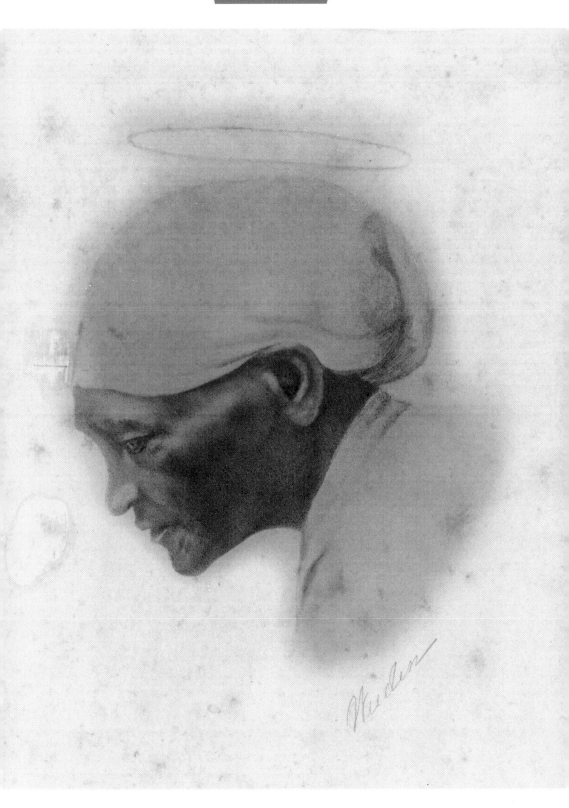

Mollie Teal

Teal (1852–1899), a Huntsville businesswoman, was better known as a madam who ran a reportedly quite successful brothel in town. She willed her house and place of business to the city in hopes that it be used for a different kind of community service. In 1904, United Charities relocated an infirmary to the house; this infirmary was part of the official Huntsville Hospital System, which had been established on Mill Street in 1895. (Courtesy of the Huntsville–Madison County Public Library Archives.)

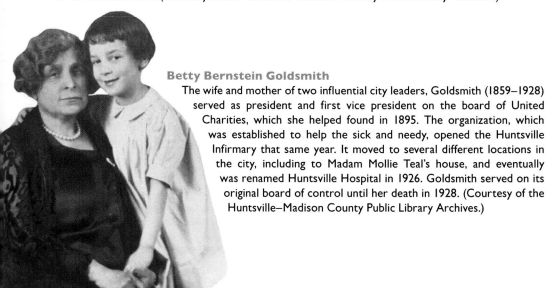

Betty Bernstein Goldsmith

The wife and mother of two influential city leaders, Goldsmith (1859–1928) served as president and first vice president on the board of United Charities, which she helped found in 1895. The organization, which was established to help the sick and needy, opened the Huntsville Infirmary that same year. It moved to several different locations in the city, including to Madam Mollie Teal's house, and eventually was renamed Huntsville Hospital in 1926. Goldsmith served on its original board of control until her death in 1928. (Courtesy of the Huntsville–Madison County Public Library Archives.)

Lily Flagg

After Signal's Lily Flagg of Huntsville won the world record for butter production at the Chicago World's Fair in 1893, *The Sydney Mail* of Australia described the Jersey cow as "perhaps not a model cow in appearance . . . [but] of good form and . . . of strong constitution. . . . She possesses that greatest of all thoroughbred gifts, the power of transmitting her good qualities to her offspring, and as she has dropped eight calves . . . the world is likely to be greatly benefited by the good work of Signal's Lily Flagg."

Previous records for yearly butter production had been set at 484 pounds, 4 ounces by an Oakes cow, and 867 pounds, 14.75 ounces by another Jersey cow. Lily Flagg, who at the time weighed 950 pounds, achieved her record by producing 1,047 pounds and three-fourths of an ounce of butter in one year. Thoroughbred and registered, she was born in 1884 and bred in Kentucky and was only one-twelfth Signal. News of her triumph spread across the country and was widely reported in periodicals, including the *New York Times*.

Lily Flagg's owner, Samuel Moore, was a planter in Huntsville who had inherited his plantation from his wealthy doctor father, who was one of three trustees of the land that Leroy Pope had deeded. Upon his return to Huntsville with his prize-winning cow, Moore threw a grand party for her. He sent formal invitations as far as Chicago, hired an Italian orchestra from Nashville, and served over 50 kinds of cake. He built a 50-foot dance platform, which was backlit by one of the first electrical lighting systems to be used in the southeastern United States. As a final touch, he painted his house butter yellow to commemorate the occasion. The Jersey cow received her long line of guests from her stable, where she stood amid abundant displays of roses.

Lily Flagg's legend continued to live on after her death. There is Lily Flagg Gin, for cotton manufacturing; Lily Flagg Village, a community in South Huntsville that was annexed into the city, whose swim team is called the Lily Flagg Cows; and the locally brewed beer Lily Flagg Milk Stout. (Courtesy of the Huntsville–Madison County Public Library Archives.)

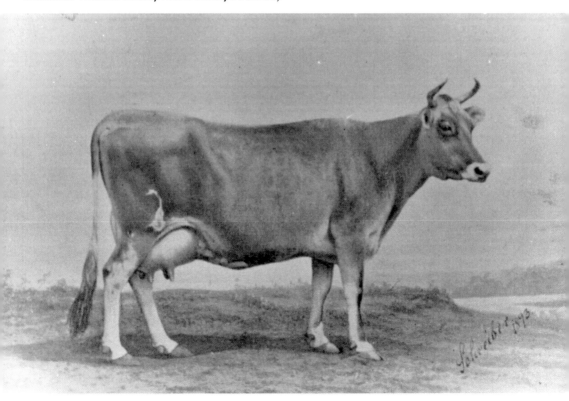

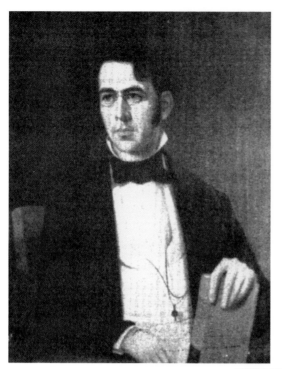

William Willis Garth

Born in Morgan County and educated at Emory and Henry College and at the University of Virginia–Charlottesville Law School, Garth (1828–1912) practiced law in Huntsville and served a term in the 45th Congress. During the Civil War, Garth acted as lieutenant colonel on the staff of Gen. James Longstreet, one of the principal generals of the Confederacy. Although Garth had no specific interest in land or railroad speculation, he served as the director of the Memphis & Charleston Railroad, which Gen. Robert E. Lee's advisors identified as the "vertebrae of the Confederacy." In 1881, Garth purchased the Drake Farm; that land was sold to the Jones family in 1939. Garth is buried in Maple Hill Cemetery. (Courtesy of the Huntsville–Madison County Public Library Archives.)

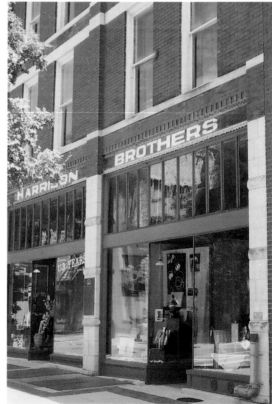

Robert Harrison

Robert Harrison (1872–1952) and his brother Daniel founded Harrison Brothers Hardware on the south side of the square in downtown Huntsville in 1897. According to local lore, the last duel in Huntsville was fought in front of Harrison Brothers in 1909 over booze or a lottery. One of the brothers was shot, but not fatally. When Robert passed away in the 1950s, his sons John and Daniel inherited the business and continued to run it as a hardware store until 1983, when John passed away. The Huntsville Historic Foundation purchased the business to preserve its legacy of quality-made products and as a model family business. The store remains true to that intention, selling high-quality local art and handcrafted local pottery, among other fineries. It still offers items the Harrison brothers would have carried, including marbles, gardening tools, and candy. The brothers' desk, ledgers, stove, safe, and cash register remain in the store. (Photograph by the author.)

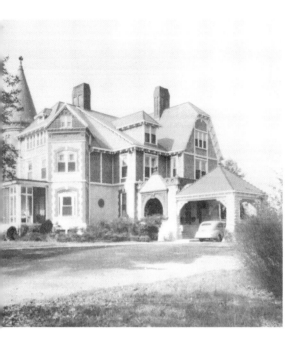

Michael O'Shaugnessy

A cottonseed oil tycoon who moved his family from Nashville to Huntsville in 1882, Michael O'Shaugnessy built Kildare (pictured), one of the most elaborate homes in Huntsville. The 40-room, 17,000-square-foot Queen Anne–style home was built on 75 acres of land and featured a variety of elaborate accents, including Hungarian vases, Japanese screens, and parlors trimmed in ebony and gold. When O'Shaugnessy went blind in 1900, his wife sold the home to the trust of Virginia McCormick, daughter of Cyrus McCormick, inventor of the mechanical reaper.

O'Shaugnessy (1861–1941) and his brother James were businessmen who built the Huntsville Cotton Oil Mill in 1881. The two also formed the North Alabama Improvement Company, which helped fund the construction of Dallas Mill and the Monte Sano Hotel, whose guests included Helen Keller and William Vanderbilt. (Courtesy of the Huntsville–Madison County Public Library Archives.)

Hawkins Davenport Westmoreland

A graduate of Nashville Medical University, Dr. Westmoreland (1873–1925) moved to Huntsville in 1904. He partnered with Dr. Felix Baldridge, and together the two helped to dedicate the operating room at Alabama A&M University. Dr. Westmoreland worked with Dr. Baldridge, who owned one of the first motor vehicles in Huntsville, to deliver babies in the early part of the 20th century. In 1905, Westmoreland became the first president of the Madison County Medical Society. He also served in World War I. He is buried in Athens City Cemetery. (Courtesy of the Huntsville–Madison County Public Library Archives.)

Isaac Schiffman

Schiffman (1856–1910) immigrated to the United States from Hoppstädten, Germany, in 1875 to work with his uncle Solomon Schiffman in his mercantile business in Huntsville. Following his uncle's death in 1894, Isaac began to buy farmland and eventually changed the name of the company from S. Schiffman & Company to I. Schiffman & Company, the name it still operates under today.

I. Schiffman & Company became involved in the investment and cotton business around the turn of the 20th century. Isaac (left) purchased the Southern Savings & Loan building on the east side of the square to house the company. He died in 1910, and ownership of the company passed to his son Robert and, eventually, to his son-in-law Lawrence B. Goldsmith Sr. Throughout the years, the company's activities have included a cattle breeding business and a Dodge dealership, and its assets have included many properties: Big Cove Farm, close to where the popular Hampton Cove community is located; Green Cove Farm near the Tennessee River, which the federal government used for the installation of Redstone Arsenal; and numerous properties in downtown Huntsville. Below, Goldsmith Jr. is pictured in the I. Schiffman Building on East Side Square in 1986. (Both, courtesy of the Huntsville–Madison County Public Library Archives.)

CHAPTER TWO

The Industry

Mills and Prosperity through the Depression

By the 1920s, the population of Huntsville had grown to 8,000, and the addition of mill villages brought it to almost 20,000. Buildings were going up all over the city, including the Terry-Hutchens building, the Huntsville Times building, and the luxury Russel Erskine Hotel (the latter two being skyscrapers). Huntsville was flourishing in spite of the impending Great Depression. The textile mills—Dallas, Merrimack, Abingdon, Huntsville, Lowe, Lincoln, and others—provided jobs and created entire communities complete with schools and churches. Dulcina DeBerry helped open the first African American library in Huntsville. Alabama A&M University continued to excel, expanding under the leadership of J.F. Drake to include more educational buildings and 600 additional acres of land. P.S. Dunnavant opened one of the first department stores, setting the standard for quality clothing and wares. Anne Clopton brought national attention to Huntsville with her unique cobweb art, and the mills continued to provide jobs and build a sense of cooperation and community among the citizens. The advent of the *Huntsville Daily Times* helped to spread the good news of exciting developments all over the city. The stage was set for the years to come. Education, art, charitable deeds, and booming commerce all played major roles in establishing an optimism that propelled Huntsville forward through the hard times of the Great Depression and into a landscape ripe for putting the city on the national map.

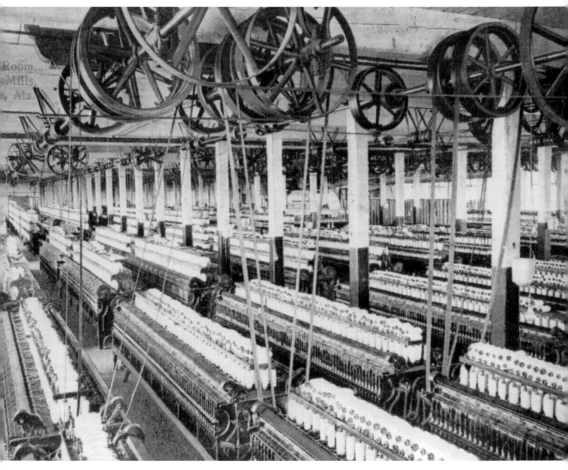

Huntsville Manufacturing Company Merrimack Spinning Room
Merrimack Mill was among several textile mills in Huntsville that contributed to both job and population growth in the early 20th century. Mill villages were complete towns in many ways, with schools and community centers, among other resources. Today, locals, including Debra Jenkins, Alan Jenkins, and Jim Hudson, have repurposed some of the mills, such as Merrimack and Lowe, into arts centers, which both serve the community and attract a number of visitors to Huntsville. (Courtesy of the Huntsville–Madison County Public Library Archives.)

Tracy W. Pratt
A northerner by birth, Tracy Pratt (1861–1922) came to be known as "Huntsville's First Citizen." At the time of his death, he was regarded as having done more for the city of Huntsville than anyone before him. Pratt's dream was for Huntsville to become the center of the textile industry in the South, and his efforts to make it so were as tireless as his vision of the city as ideal for industrial investment.

Born in Minnesota, Pratt owned the West Huntsville Cotton Mill and several properties in the East Huntsville addition, and was constantly speculating on land in Huntsville that would be suitable for textile mills. He had connections to Merrimack Manufacturing in Lowell, Massachusetts, and knew that the company wanted a plant in the South. After one unsuccessful showing of a prospective property following a flood and Merrimack's refusal to buy, Pratt pleaded with the company to visit during drier days and worked with them to secure a quote for 1,385 acres. The company broke ground on July 4, 1899.

The arrival of Merrimack in West Huntsville precipitated a need for a streetcar connecting Dallas Mill village in East Huntsville, West Huntsville, and downtown Huntsville. The Huntsville Railway, Light & Power Company was organized in July 1899 with a capital stock of $100,000. Pratt invested $99,700 in the initiative. The streetcar opened up East Huntsville, made it an accessible and desirable place to live, and created what is now known as Five Points. Pratt also built houses for the Merrimack Mill workers, created a communal garden for produce, and allotted space behind the houses for cattle. By 1913, Merrimack Mill Village had a bike shop, company store, school, bank, grocery, and meat market.

Pratt died in 1922. Huntsville businesses closed citywide for the first five minutes of his funeral out of respect for the man who had done so much to bring industry to Huntsville and to create community within its previously segmented city limits. (Courtesy of the Huntsville–Madison County Public Library Archives.)

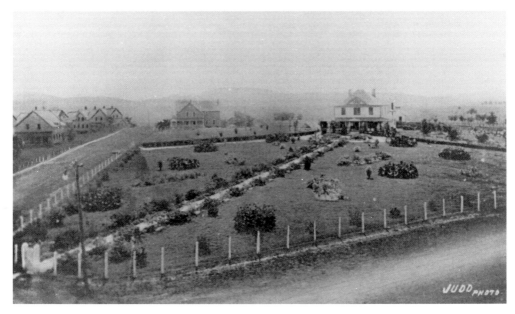

Searcy W. Judd

Originally from Chattanooga, S.W. Judd (1880–1960) made his mark on Huntsville not only as a renowned photographer, but also as an X-ray operator. Judd Studio was initially located on the southeast corner of the square, but Judd eventually moved to a studio on Eustis Avenue. He was of great help to local physicians with his keen eye and meticulousness, and had a virtual monopoly on X-ray work in the South. This photograph of the Merrimack Mill community is by Judd. (Courtesy of the Huntsville–Madison County Public Library Archives.)

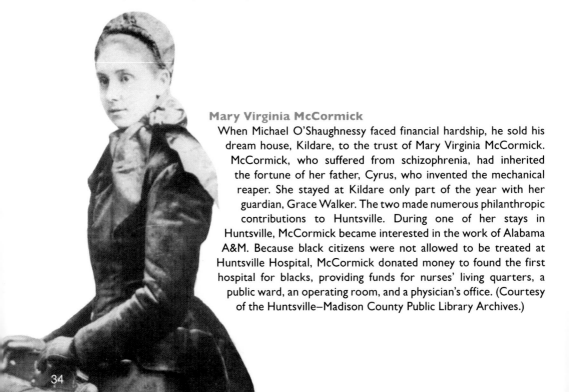

Mary Virginia McCormick

When Michael O'Shaughnessy faced financial hardship, he sold his dream house, Kildare, to the trust of Mary Virginia McCormick. McCormick, who suffered from schizophrenia, had inherited the fortune of her father, Cyrus, who invented the mechanical reaper. She stayed at Kildare only part of the year with her guardian, Grace Walker. The two made numerous philanthropic contributions to Huntsville. During one of her stays in Huntsville, McCormick became interested in the work of Alabama A&M. Because black citizens were not allowed to be treated at Huntsville Hospital, McCormick donated money to found the first hospital for blacks, providing funds for nurses' living quarters, a public ward, an operating room, and a physician's office. (Courtesy of the Huntsville–Madison County Public Library Archives.)

Samuel R. Butler

Butler (1868–1947) attended Madison County public schools and, after graduating from Winchester Normal College in Winchester, Tennessee, went on to become superintendent of the Madison County Public School System from 1905 to 1931. Butler was the owner and principal of the Butler Preparatory School, which he founded in 1908, and which was located in a building on the corner of Franklin and Gates Avenues. The school relocated one year later to a building Butler had constructed for it—a brick, two-story structure with a bell tower (below) that would be home to distinguished private schools, including the Willis Taylor School, for the next 20 years. Butler Preparatory School was coeducational and non-denominational, and was well regarded for its commitment to excellence in education. It offered courses in English, science, history, math, music, German, French, and Latin. By 1910, the school had its own football team.

Due to his concurrent commitment as superintendent of the Madison County Public School System, Butler sold the school approximately five years after it opened. S.R. Butler High School on Holmes Avenue is named in his honor. (Both, courtesy of the Huntsville–Madison County Public Library Archives.)

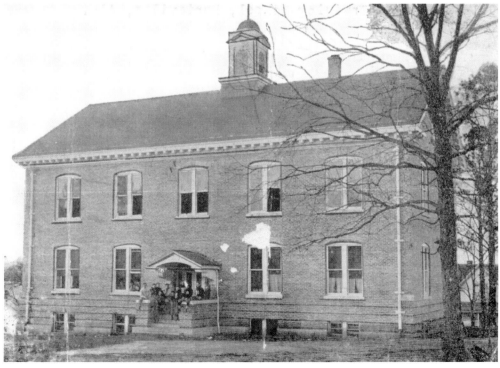

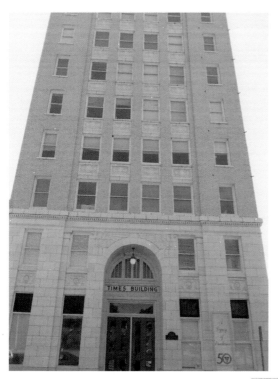

J. Emory Pierce

Pierce (1880–1952) founded the *Huntsville Daily Times* in 1910 and served as its first president and editor. In the late 1920s, he saw a need to expand the paper's facilities and hired the South's premier architecture firm, R.H. Hunt of Chattanooga, to design the 12-story Art Deco building that currently stands on the corner of Greene Street and Holmes Avenue. The building was one of two skyscrapers in Huntsville at the time; the other was the Russel Erskine Hotel.

During the Depression, Pierce defaulted on his loans and lost both the paper and the building in 1931, when it was bought at auction by the *Birmingham News*. It has changed hands a number of times since. The word "daily" was removed from the paper's name in 1931. (Photograph by the author.)

P.S. Dunnavant

P.S. Dunnavant (1886–1974) opened one of Huntsville's first department stores in 1914 at the corner of Washington Street and Clinton Avenue. Folks traveled from all over North Alabama and southern Tennessee for its fine-quality merchandise and courteous service. Dunnavant, considered innovative in pioneering the American mall, would greet customers at the door. By 1955, the store employed over 100 people. Dunnavant's Department Store eventually moved to the corner of Governors Drive and Memorial Parkway. Huntsville's four original malls, including Dunnavant's Mall, Heart of Huntsville, The Mall, and Parkway City, were all located on Memorial Parkway. Dunnavant's closed in 1969. (Courtesy of the Huntsville–Madison County Public Library Archives.)

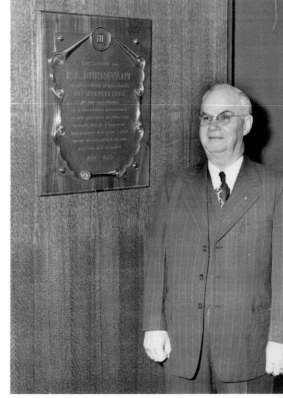

W.C. Handy
Known as the "Father of the Blues" for being among the first musicians to notate blues chord progressions, William Christopher Handy (1873–1958) was born in Florence, Alabama. While touring through Huntsville with the group Mahara's Minstrels in 1900, Handy and his recent bride stayed in Florence, where their child was born in June of that year. William Hooper Councill, president of Alabama A&M, approached Handy at that time and offered him a position as band director and music teacher. Handy taught for almost two years at the school before falling out with the administration over the serious merit of American music. He found greater job stability touring with groups and following his passion. Handy left the university and went on to make an indelible mark on American blues history. He is perhaps best known for his publication of the sheet music for "Memphis Blues" (1912), which highlights the 12-bar blues progression. In 1914, "Memphis Blues" became the first blues track ever to be put on a record. (Courtesy of the Florence Department of Art and Museums, Florence, Alabama.)

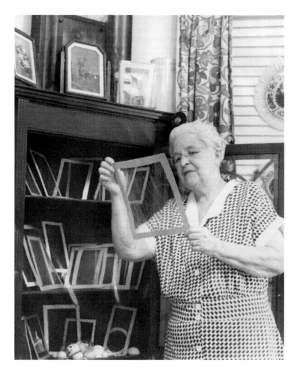

Anne Bradshaw Clopton

In spite of initial skepticism not only of her art form, but also of the validity of the piece itself in its finished state, Anne Bradshaw Clopton (1878–1956) persevered throughout her life to construct beautiful images in paint on delicate cobwebs. Initially from Shelbyville, Tennessee, Clopton grew up in Huntsville and was the daughter of a teacher. A student of Latin, Greek, and other topics, Clopton was inspired by a German artist whose unique medium she felt she could replicate.

Anne's art faced numerous challenges, first among them the fact that her German predecessor painted on cobwebs much thicker than those produced by spiders in Huntsville. Initially, she painted with watercolor in a stippling technique, one dot after the next, to create an image. As the web dried overnight, she would find that the spider had woven a web of gauze over the image, which would have to be cleared away. In response, Clopton developed a method by which she slid a cardboard frame behind the web and pulled it from its initial spot; the web would stick to the cardboard, and she could carry her canvas off to her modest studio without the threat of the web's original owner erasing her image.

Clopton faced many challenges throughout her career, including skepticism that the spiderwebs were real. She devised a way to exhibit her paintings between panes of glass, a method that also kept the webs from disintegrating after prolonged exposure to air. She also exhibited her works in old watch cases fashioned into wearable lockets.

Following a likely case of polio as a young adult, which left her blind for almost two years, Clopton changed her technique to leave intentional holes in her paintings so that the cobweb itself would be visible. A painting would take about a month to finish.

Clopton displayed her works at two world's fairs; was featured in magazines; appeared on at least two radio shows in New York City; was featured in several films, including *Stranger than Fiction* and *Industry on Parade*; and had works in the Ripley's Believe it or Not! Museum. She married Blunt Clopton, a farmer and businessman, in 1906 and taught math and Latin at the Merrimack school, later Joe Bradley School. She eventually lost her eyesight, with which she struggled her entire life following her illness, and died at home in 1956, having painted almost 700 cobwebs. Though her collection is housed at the Burritt Museum in Huntsville, her works reached into many corners of the globe. (Courtesy of the Huntsville–Madison County Public Library Archives.)

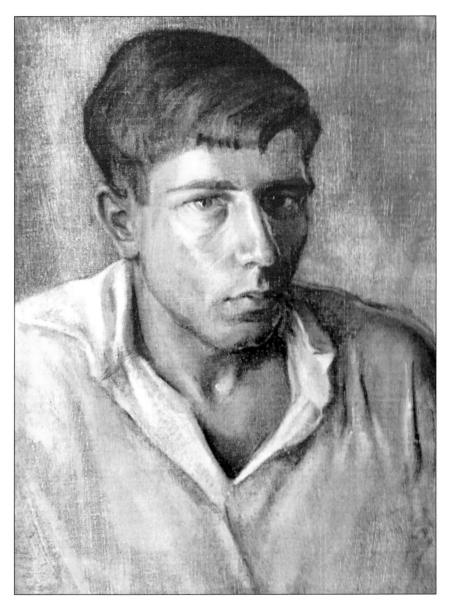

Maurice Grosser

A world traveler and painter who hung out with such notables as Georgia O'Keeffe, Virgil Thompson, and Gertrude Stein, Maurice Grosser (1903–1986) was born in Huntsville, Alabama, and attended the Wills Taylor School as a child. Following his graduation from high school in Tennessee, Grosser attended Harvard University, graduating with honors in 1924 with a degree in mathematics. He then traveled and painted in France and Italy for the next two years on a fellowship awarded him by Harvard.

With a style classified as "conservative realist," Grosser excelled in numerous genres, including portraiture. He worked with opera composer Thompson on more than one occasion, and twice on a collaborative effort between Thompson, with his opera, and Stein, with her libretto. Grosser was a writer and critic for *The Nation* for over 10 years. At the time of his death, he was working on a memoir, *Visiting with Gertrude Stein and Alice Toklas.* His remains are interred at Maple Hill Cemetery. (Courtesy of Margaret Anne Goldsmith.)

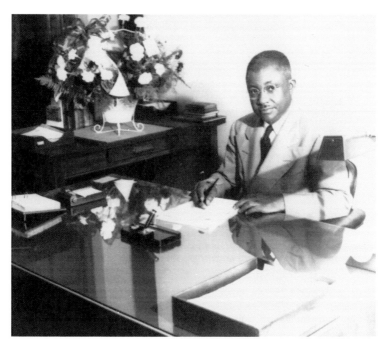

Joseph Fanning Drake

Dr. J.F. Drake (1892–1964) was the fourth president of Alabama A&M University, serving from 1927 to 1962 and as president emeritus until his death in 1964. Drake attended Talladega College and earned his masters at Columbia University and his PhD at Cornell, another land-grant university, like A&M.

Known as "The Builder" at A&M, Drake directed the construction of an extraordinary number of buildings on campus, including 20 farm buildings, its first greenhouse, teachers' cottages, a dining hall, a gymnasium, and a science center. He also added over 600 acres to the school. Known also as "The Savior," Drake guided the university through the Depression and the early part of the civil rights movement. He is credited in large part for keeping the school from being closed due to any number of factors during such critical and difficult times. The university more than tripled in faculty size and in student enrollment during Drake's tenure. (Both, courtesy of the Huntsville–Madison County Public Library Archives.)

Albert Russel Erskine

Erskine (1871–1933) had an entrepreneurial sense about him from the beginning. When he was 15, he made a small business of selling apples on the train when it pulled into the local station. After years of attending public and private Huntsville schools, Erskine dropped out and became an office boy at the railroad station and, shortly thereafter, a bookkeeper.

Erskine soon accepted a position as chief clerk at the American Cotton Company in St. Louis and later as the vice president of the Underwood Typewriter Company from 1910 to 1911. In October 1911, based on his expertise in accounting, he took a job with the Studebaker Corporation, manufacturer of carriages and, eventually, automobiles. Within four years, he was president of the company.

Following the unsuccessful introduction in 1926 of "The Erskine" model car at the Paris automobile show, Studebaker pulled the model entirely in light of its poor reception and the poor national economy. Erskine turned his attention toward an endeavor by six Huntsville businessmen to build a luxury hotel. He agreed to help fund the project only if the hotel was named after him rather than Joe Wheeler, its original namesake. The Russel Erskine hotel opened in 1930 in grand fashion. It was 12 stories tall, with 150 guest rooms and an ornate ballroom, marble staircases, and gorgeous vistas of a blossoming city.

In 1933, Studebaker went into receivership in the midst of a struggling economy. Depressed and in poor health, Erskine committed suicide in South Bend, Indiana, leaving a note specifying that his funeral be private; at the service, police officers were stationed outside to check the names of guests before they were permitted to enter.

Though Erskine only made partially good on his promised investment, the luxury hotel, which was converted in the 1980s to apartments for assisted living, still bears his name. Erskine is buried in his family's mausoleum in Maple Hill Cemetery. (Both, courtesy of the Huntsville–Madison County Public Library Archives.)

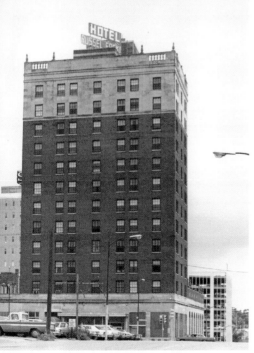

Dulcina DeBerry

When the director of the Regional Library Services handed Dulcina DeBerry (1878–1969) a key to a dark, dank room in the basement of Lakeside Methodist Church at the end of May 1940, he gave her 10 days to transition the space into a functional library for the African American community of Huntsville. With two high school boys and some paint, a group of young girls who brought potted flowers, and the gift of a chair from the minister's wife, DeBerry brought to life the first African American branch library in Huntsville.

Dulcina DeBerry, a graduate of Shaw University and a former schoolteacher in North Carolina and Talladega, Alabama, was an active member of Lakeside Methodist. Her mother's illness had brought her to Huntsville, where she had been caring for her. The basement library began with just 27 young-adult books, 39 adult books, and 10 magazines on its opening day, June 10, 1940. After just three years under DeBerry's direction, the collection had grown to over 4,000 books and 12 magazine subscriptions. Through such programs as the Vacation Reading Club and Friday Children's Hour, DeBerry reached out to children in the African American community, encouraging them not only to meet their school reading requirements, but also to explore a love of literature beyond what was expected.

The rapid growth of library programs inspired the formation of a board to offer consistent sponsorship and support. Eventually, the branch outgrew itself and moved into a room at the Winston Street School (which was demolished in the 1980s to build Interstate 565), part of Pres. Franklin Roosevelt's Work Projects Administration. Through various fundraisers, including a musical benefit, the library raised enough money for chairs, magazine racks, display shelves, and library tables; the musical benefits continued until 1952 and helped to sustain the library. In 1943, when Roosevelt dissolved the WPA, the Huntsville Library Board assumed full operative and financial responsibility for the branch library, retaining DeBerry at its helm. The branch moved again in 1947 to Pelham Avenue and soon after was renamed the Dulcina DeBerry Library, which at this point had over 5,400 books in circulation and distributed over 1,500 books and magazines to the community as part of its summer reading program.

In 1951, DeBerry moved home to Raleigh, North Carolina, and later to Cleveland, Ohio, where she died in 1969 at the age of 91. Following several more moves, the arrival of urban renewal in Huntsville in the 1960s, and the library system's resort to bookmobiles, the Dulcina DeBerry Library closed on October 1, 1968. (Courtesy of the Huntsville–Madison County Public Library Archives.)

John Rison Jones Jr.
A graduate of Huntsville High trained as an infantry sharpshooter, John Rison Jones (1924–2008) was a US Army rifleman with the Timberwolf Division, which arrived at the Dora-Mittelbau concentration camp in Nordhausen, Germany, near the end of World War II. The Timberwolves found over 3,000 people dead and more than 750 starving. The troops found medical assistance for the survivors and participated in the burial details of the deceased prisoners. Jones, who had received a Leica Model III portable 35-millimeter camera as a gift prior to his deployment, photographed much of what he saw at the camp and had documented his entire tour on film since landing in France in September 1944. For his bravery and meritorious service, Jones received a Bronze Star.

After his demobilization from the Army in 1946, Jones attended the University of the South, where he studied history, always struggling with the injustices of an unequal and racially segregated South. He went on to earn a doctorate in French history from the University of North Carolina–Chapel Hill in 1958 and proceeded to teach history at both Southern Methodist University and Washington and Lee. Although he also worked as a diplomatic historian for the US State Department, Jones always felt that his academic pursuits kept him from being useful in solving current world problems.

Jones turned his passion for working with poor and minority youth into a position with the Office of Economic Opportunity in Washington, DC, held positions in the Department of Education, and won the Department of Health, Education, and Welfare's highest civilian award for outstanding service. After his retirement, he returned to Huntsville in 1987, actively contributing to the preservation of historic buildings and being an integral part of the Huntsville–Madison County Historical Society. In 1994, he spoke publicly about his experience in Nordhausen and was adamant about educating people on the horrors and reality of the Holocaust. (Courtesy of the University of Alabama Huntsville Salmon Library Archive.)

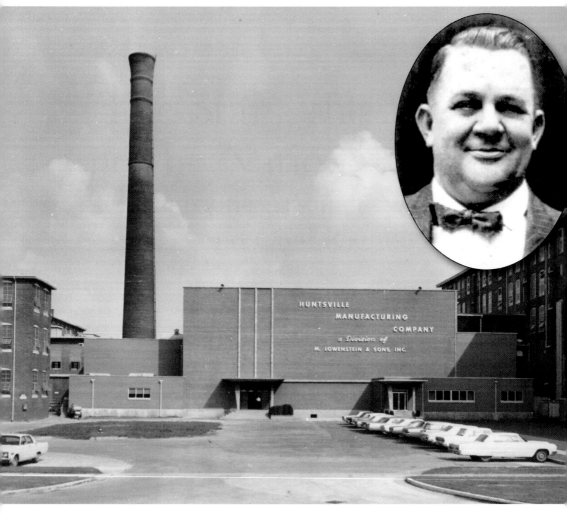

Joseph Bradley Sr.

Five years after Merrimack Manufacturing of Lowell, Massachusetts, opened its textile mill in Huntsville, Joseph Bradley (1868–1922) of Pennsylvania became its manager and began to implement and oversee changes that fundamentally sustained the Merrimack Mill community for the next 50 years. Among his accomplishments as an advocate for his employees was a small hospital for the workers, a beautification program for the mill grounds, and a school that operated from 1914 until the late 1970s. The mill workers took great pride in the school's football team.

When Merrimack Mill switched to electric power from steam in 1920, the new Merrimack Hall became the site of a gymnasium, library, café, barber shop, drugstore, and company store. The mill's newspaper, *The Merrimacker*, eventually became the popular *Huntsville Parker*. In 1951, almost 30 years after Bradley's death, the streets in the mill village were paved for the first time.

"Big Joe's" advocacy for and pride in Merrimack Mill village and for its employees left a legacy on that area that continues today in its current incarnation as home to an arts education facility that serves over 500 children in the community. (Both, courtesy of the Huntsville–Madison County Public Library Archives.)

CHAPTER THREE

The Stars, the Moon, and the National Terrain
Redstone Arsenal, NASA, and Civil Rights

During World War II, Huntsville was chosen as the location for a chemical weapons production and storage plant. Huntsville Arsenal opened in 1941. An additional assembly plant, known as the Redstone Ordnance Plant, was opened shortly after and renamed Redstone Arsenal in 1943. Wernher von Braun and his team of 120 German scientists arrived in 1950, and Redstone's focus expanded from rockets to missiles. Von Braun encouraged the establishment of the University of Alabama in Huntsville in order to have the science and engineering infrastructure to support the rocketry program. Von Braun moved from the Army to NASA 12 years later as the first director of the Marshall Space Flight Center. Huntsville was poised on the cutting edge of space exploration.

Rocket science was not the only thing going on in Huntsville though. The early 1960s saw a concerted and successful effort toward the establishment of a viable arts community, with the organization of Huntsville Civic Ballet and Community Ballet, Fantasy Playhouse, the Huntsville Symphony, and the Arts Council, all of which remain influential in the community today.

Also in the 1960s, the Huntsville Airport Authority sought a site for a small airport; eventually, the Port of Huntsville expanded to include the International Airport, the Jetplex, the Industrial Park, and the International Intermodal Center, making Huntsville a hub for transportation and commerce.

Huntsville native and civil rights activist Dr. Sonnie Hereford III filed a lawsuit for his son to attend an all-white school, making him the first black student to attend a white public school in Alabama. Joseph Lowery, another civil rights activist, carried his passion from Huntsville to Selma, Montgomery, and eventually, to the presidency of the Southern Christian Leadership Conference.

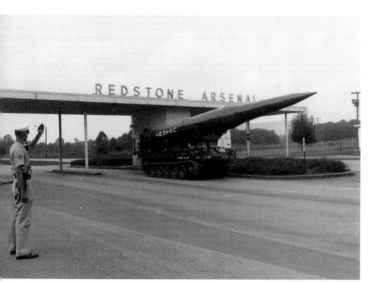

Redstone Arsenal Entrance
Following World War II, Huntsville Arsenal was going to be put up for sale, as it was no longer deemed useful as a chemical weapons production and storage facility. However, the Army discovered it could utilize the land for a new mission being developed at adjacent Redstone Arsenal, and consolidated the two arsenals in 1951. Wernher von Braun had arrived on the Huntsville scene the previous year. (Courtesy of the Huntsville–Madison County Public Library Archives.)

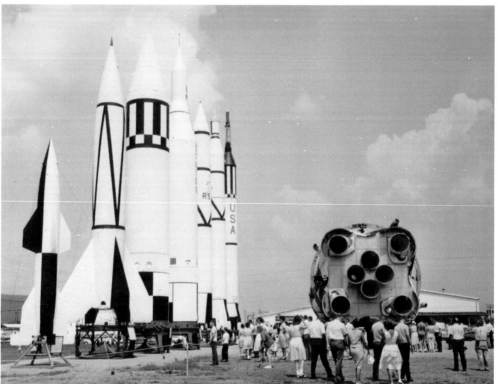

Redstone Arsenal MSFC Space Orientation Center 1968
A hint of things and museums to come, the Marshall Space Flight Center Space Orientation Center, featuring space-related exhibits, was opened to the public beginning in the early 1960s. By 1970, the US Army had donated part of Redstone Arsenal's land for the establishment of a space museum, the US Space & Rocket Center, at the urging of Wernher von Braun. Today, the center attracts over 600,000 visitors each year with its exhibits and programs, including the internationally known Space Camp. (Courtesy of the Huntsville–Madison County Public Library Archives.)

Lawrence Bernstein Goldsmith Sr.

Born in Huntsville and educated at the Weingart Preparatory School for Jewish Boys in New York City, Lawrence Goldsmith (1883–1973) returned to his hometown at age 19. He married his childhood sweetheart, Annie Schiffman, in 1908. One year later, he joined his father-in-law, Isaac Schiffman, in business at I. Schiffman & Company, of which he eventually became president. During his time with the company, he managed real estate holdings and farm properties, managed family estates and affairs, and operated a Dodge dealership.

A 32nd-degree Mason and a member of both the Kiwanis and Elks clubs, Goldsmith also served on the board of education and on the first board of the Huntsville Electric Utility. He was active in the Boy Scouts of America and was influential in Huntsville's Jewish community as chair of the budget and finance committee of Temple B'Nai Sholom and as manager of the Jewish section of Maple Hill Cemetery.

In the late 1920s, Goldsmith organized a group of businessmen to finance the construction of Huntsville's first grand hotel, the Russel Erskine, and saw it through a successful opening in spite of the Depression. In 1938, Goldsmith was one of the individuals appointed by the chamber of commerce to take government officials around the Tennessee Valley in their quest for a location for a large munitions storage complex. He was instrumental in securing the location of the munitions complex in Huntsville; today, it is known as Redstone Arsenal. (Courtesy of Margaret Anne Goldsmith.)

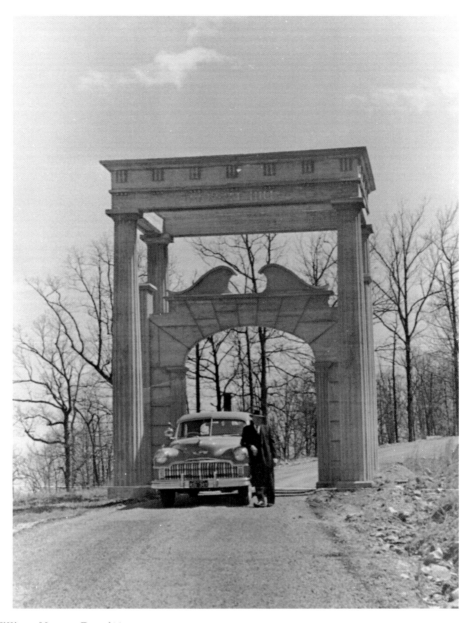

William Henry Burritt

Born in Huntsville, Dr. William Burritt (1869–1955), homeopathic doctor and inventor, attended Vanderbilt School of Medicine and returned to Huntsville in 1891 to care for his ailing mother. After spending time in Denver, Colorado, where he married in 1892, Burritt and his wife returned to Huntsville. His first wife, Pearl, died in 1898 from complications from surgery. The next year, Dr. Burritt, who received his Alabama Medical Association certificate in 1897, met Josephine Drummond of St. Louis, a widow and heir to the Drummond Tobacco Company fortune who fell ill while visiting Huntsville. She and Burritt married in 1899, and Dr. Burritt retired his practice to become Josie's personal physician. They returned to St. Louis, where Burritt was actively involved in the community. They lived there for many years until Josie's death in 1933. While in St. Louis, Burritt patented a number of tires and wheels in his newly found spare time since retiring as a doctor. (Courtesy of Burritt on the Mountain.)

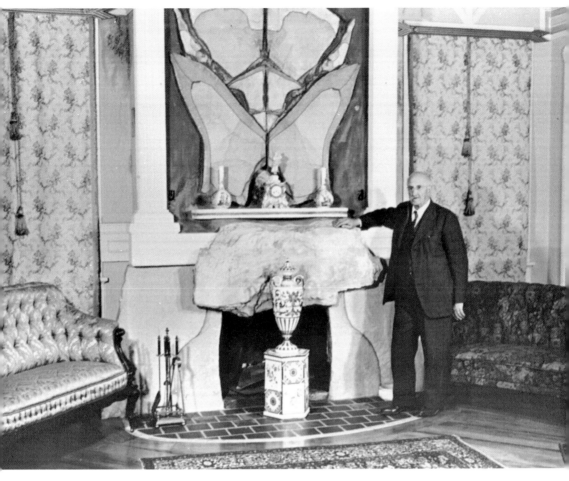

Life on Round Top Mountain

Having inherited much of Josie's fortune, William Burritt returned to Huntsville once again and purchased 167 acres of land on Round Top Mountain. He proceeded to build his retirement home in 1934, using a number of recycled materials and other sustainable architectural tools, including wheat straw for insulation. In order to keep the rats out of the straw, he lined the basement with metal, which, in conjunction with the electricity he was able to run to his house, caused a short circuit that started a fire. The house burned to the ground the day before he was supposed to move in. Burritt rebuilt, adding a giant cistern to the side of the house, ever mindful of the possibility of fire. Maintaining his green-mindedness, Burritt used more concrete the second time and built the house in the shape of a Maltese cross, allowing ventilation throughout and wonderful views from all sides.

Burritt, who was blind in one eye, had a car specially designed for him with the wheel on the right side, so that he could see the mountainside while driving up to his home. He did not believe in using hot water, and plumbed the house only for cold water; it is rumored that this led to his divorce from his third wife in 1949. He had a goat dairy farm and vegetable farm on Round Top Mountain.

Burritt lived on Round Top until his death in 1955. His concern about the rapid development of Huntsville, through such facilities as NASA and Redstone Arsenal, led him to will his home, farm, and surrounding woods to the city as its first museum and as a public park. Today, the museum, which includes his mansion, features a historic park showcasing period homes as well as nature trails and a number of educational programs. It is a popular and sought-after site for weddings, galas, and other events. (Courtesy of Burritt on the Mountain.)

Helmut Hoelzer

A German electrical engineer, remote-control guidance specialist, and member of Wernher von Braun's long range rocket development team in Peenemünde, Germany, Helmut Hoelzer conceived a design for an electronic analog computer in 1935. With the help of an assistant, Hoelzer built the first fully electronic analog computer in 1941. Hoelzer (1912–1996) called the device the 50 Jahre Analog Computer; it was first used in the guidance system of the A4 rocket. Hoelzer was the head of the Computation Laboratory at the George C. Marshall Space Flight Center in Huntsville. He was born in Bad Liebenstein, Thüringen, and came to Huntsville via Fort Bliss, Texas, with von Braun's team as part of Operation Paperclip. He died in Huntsville at the age of 84. Above, the Peenemünde team is pictured at Redstone Arsenal. Hoelzer is second from left, next to Ernst Stuhlinger. (Left, courtesy of The Huntsville Times/Al.com; above, courtesy of NASA.)

Tallulah Bankhead

A well-known stage, film, and radio actress born in an apartment in the Schiffman building in downtown Huntsville, Bankhead (1902–1968) was the daughter of William Bankhead, a prominent Huntsville attorney who later served as speaker in the US House of Representatives. Though Tallulah Bankhead did not immediately find success as a Broadway actress, she was quite popular in London's West End theater district. She eventually experienced a bit of a revival as an actress in Hitchcock's film Lifeboat in 1944. Known to love a live audience and to be a little raucous, affectionately wild, and famously unrefined, Bankhead's oft-uttered phrase, "Hello, dahling" still brings her legend to mind today. (Courtesy of the Huntsville–Madison County Public Library Archives.)

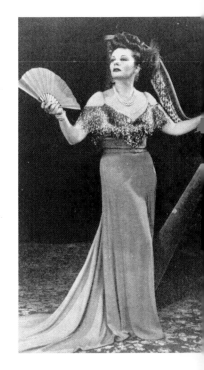

John Sparkman

Sparkman (1899–1985) grew up in Hartselle, graduated from Morgan County High School, and worked his way through the University of Alabama, earning bachelor's, master's, and law degrees. He opened his practice in Huntsville in 1925.

Sparkman served in Congress for 42 years, first as a member of the House and then as a senator from 1946 until 1979. He was concurrently elected to both the House and the Senate in 1946—reelected as a representative and elected for the first time as senator to fill the seat of John Bankhead, who had died earlier that year.

Sparkman served on the Senate Foreign Relations Committee, the Senate Select Committee on Small Business, and the Senate Committee on Banking, Housing, and Urban Affairs from 1967 to 1974. He was the vice presidential candidate on the Adlai Stevenson presidential ticket in 1952.

In 1953, Sparkman contributed to the report that discredited Sen. Joseph McCarthy's accusation of Charles Bohlen's involvement in communism. Sparkman called out McCarthy in front of the entire Senate.

Sparkman was an essential part of bringing von Braun's team of German rocket scientists to Huntsville. His other civic contributions and responsibilities to the city included serving as district governor of the Kiwanis Club of America and president of the Huntsville Chamber of Commerce. (Courtesy of the Huntsville–Madison County Public Library Archives.)

Otis Gay

Dr. Otis Gay (1910–2000) came to Huntsville in 1950 to direct the Madison County Health Department. A graduate of the University of Georgia with a medical degree from Tulane University, Dr. Gay earned his master's in public health, also from Tulane. He served in the US Army from 1942 to 1946.

Dr. Gay was very outspoken about his medical opinions, expressing particular distaste for parents who did not inoculate their children against polio, an epidemic that reached its height in the United States in 1952. He was also involved in rabies immunizations and was instrumental in the success of the Maternity and Child Health Center in neighboring Triana.

Under Dr. Gay's direction, the Madison County Health Department was regarded as one of the most efficient health departments in the state. Among his many honors, he received a distinguished citizen award from the chamber of commerce in 1975 and an honorary law degree from the University of Alabama in Huntsville in 1975. Mayor Joe Davis declared January 15, 1980, Dr. Otis F. Gay Day. (Courtesy of the Huntsville–Madison County Public Library Archives.)

Sarah Huff Fisk

Historian and preservationist Sarah Huff Fisk (1916–2006) was a native and lifelong resident of Madison County. During her 35-year tenure as bookkeeper and historian for the Huntsville Manufacturing Company, she edited *The Huntsville Parker*, the newspaper for that community. Among her many civic contributions, Fisk was president of the Huntsville–Madison County Historical Society for many years, served on the board of Constitution Hall Park, and chaired the committee that erected many of the historical markers throughout the county. Fisk's illustrations appeared in several Alabama school textbooks, and she produced a drawing of the square for Huntsville Utilities and "A New Map of Huntsville 1819."

Fisk authored six books, including as co-author of *The Lost Writings of Howard Weeden as Flake White* and *Shadows on the Wall: The Life and Works of Howard Weeden*. Fisk's meticulous, intricate, and functional notecard system, in which she cataloged and cross referenced everything from newspaper articles to maps organized by lot numbers, is housed at the Huntsville–Madison County Public Library. (Courtesy of the Huntsville–Madison County Public Library Archives.)

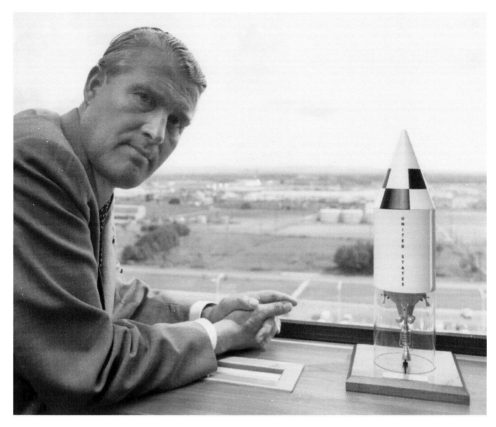

Wernher von Braun (ABOVE AND OPPOSITE PAGE)
Long a champion of space exploration, German-born rocket scientist Wernher von Braun came to Huntsville via Fort Bliss, Texas, and New Mexico in 1950 after he and his team of over 100 scientists surrendered their secret laboratory in Peenemünde to the Americans in World War II. Von Braun (1912–1977) was well known as the leader of the rocket team that developed V2 missiles for the Nazis during the war.

He and his team continued their work on ballistic missiles in the United States, and they all moved to Huntsville in 1950. In 1960, two years after the National Aeronautics and Space Administration was established, von Braun's rocket center was moved from the Army to NASA, and he was appointed the first director of the Marshall Space Flight Center. Von Braun was the chief architect of the Saturn V rocket, which first launched in 1967 and which eventually launched Americans to the moon as part of the Apollo missions. Saturn V had 13 missions, the last one in 1973, when it launched the Skylab space station into Earth's orbit. The first Saturn V rocket is on display inside Huntsville's US Space & Rocket Center's Davidson Center for Space Exploration; it is one of only three Saturn rockets in existence.

In addition to securing funding for the development of the Space & Rocket Center, von Braun directed an effort that contributed directly to a population boom in Huntsville. With the lure of the space program through the first half of the 1960s, Marshall Space Flight Center employed 7,500 individuals and an additional 5,300 contract employees at Redstone Arsenal. Of the $1.8 billion budget in 1966, ninety percent went to Huntsville. The city's population grew from 17,000 in 1950 to 140,000 by 1970.

Much to the disappointment of its residents, Von Braun left Huntsville in 1970 to work in strategic planning for NASA in Washington, DC. He died in Alexandria, Virginia, in 1977. His legacy lives on through the many artifacts he procured for the US Space & Rocket Center, through its educational mission, and through such programs as Space Camp, a space-simulation program that draws thousands each year from around the world. (Both, courtesy of the Huntsville–Madison County Public Library Archives.)

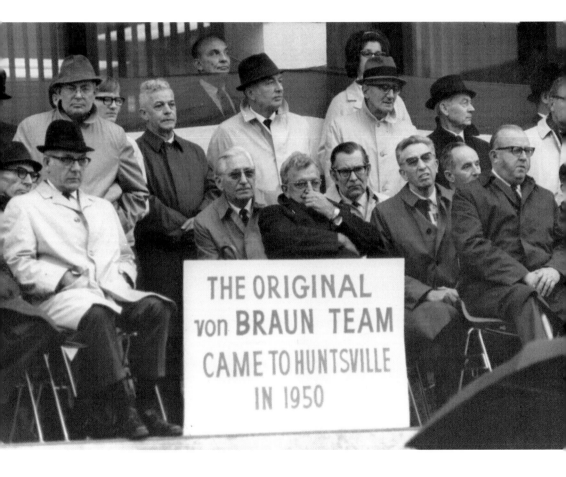

THE ORIGINAL von BRAUN TEAM CAME TO HUNTSVILLE IN 1950

Chessie Walker Harris (OPPOSITE PAGE)

Born to a sharecropper in Tuskegee, Alabama, Chessie Harris (1906–1997) noticed from a young age the lack of services available to poor, homeless, and hungry children, and sought to do something about it. After several years as a student at Tuskegee, Harris's family moved to Cleveland, Ohio—a place Harris tried to love, but never fully embraced.

While there, she convinced her parents to take in foster children, and she continued to advocate for children. She met George Harris in 1931, and they married two years later. The couple had four children. When their eldest son sought to attend a Christian school in 1949, he enrolled in Oakwood Academy; concurrently, Oakwood College offered both Mr. and Mrs. Harris jobs on campus as grounds superintendent/farm manager and food service director, respectively. The family moved to Harris's beloved Alabama.

After work, Harris would venture downtown with food from her job at Oakwood; she also brought needy children to her own home to feed and bathe them. Though she received a rather dismissive response when she approached child welfare workers about the lack of services for so many children, black children in particular, the welfare department agreed to do a home study and gave Harris and her husband a foster boarding license in 1954. The Harrises sold their farm in Ohio and eventually built a bigger house; the Harris Home for Children (below) was licensed by the State of Alabama in 1960.

Today, the Harris Home for Children provides shelter and services such as tutoring, mentoring, cooking skills, and job application skills to about 40 children ages 12–21 at any one time. Harris, who has an honorary doctor's degree in humanities from Andrews University, was honored by Pres. George Bush in 1989 as a recipient of the Presidential Volunteer Action Award. The Alabama state senate declared July 6, 1986, Chessie Harris Day. For health reasons, Harris retired as director of the Harris home in 1980; she died in 1997. (Both, courtesy of the Huntsville–Madison County Public Library Archives.)

Harry Rhett Jr.
The son of Harry Rhett Sr., who managed the land bounded by Governors Drive, Whitesburg Drive, Drake Avenue, and Leeman Ferry that flourished and was developed in the 1950s, Harry Rhett Jr. (1912–1996) continued his father's interest in the city as a real estate and agriculture investor. A graduate of Culver Military Academy, Washington and Lee University, and Harvard University Business School, as well as a World War II veteran, Rhett served in numerous capacities in the community, including as president of the Madison County Board of Registrars, the Twickenham Historical Preservation District, the chamber of commerce, the Rotary, and the Marshall Space Flight Center Community Advisory Committee. Additionally, he was chair of both the Huntsville Gas and Huntsville Water Utility boards, the Randolph School board of trustees, and the Huntsville Hospital Foundation. Rhett was respectfully remembered for his humility and his vast contributions to the development and well-being of the city during a period of rapid change and growth. (Courtesy of the Huntsville–Madison County Public Library Archives.)

William L. Halsey III

Will Halsey (1920–2015) was a businessman and civic leader who was a driving force in the commercial and educational opportunities of the Huntsville and Madison communities. He played a key role in the integration of Huntsville City Schools, served on the committee that formed the University of Alabama in Huntsville, and helped raise the money to start the school. As president of the chamber of commerce in 1955 and as chair of the Huntsville Army Advisory Committee from 1967 to 1992, he helped bring business to Huntsville during the growth of NASA's Marshall Space Flight Center and Redstone Arsenal. Halsey was past director of First Alabama Bank, SCI, the University of Alabama Huntsville Foundation, and other organizations, and served as chair of the Huntsville City School Board.

A member of the third generation to run Halsey Grocery Company, Halsey retired as its CEO in the early 1990s. He graduated from the Gulf Coast Military Academy and from the University of Alabama, and served in the Engineer Amphibian Command in World War II. He had an honorary law degree from the University of Alabama in Huntsville and was the recipient of a chamber of commerce Distinguished Service Award. (Above, photograph by the author; right, courtesy of the Huntsville–Madison County Public Library Archives.)

Frances Cabannis Roberts

Although she preferred working in the background and sustaining the work of an organization rather than leading it, Frances Cabannis Roberts (1916–2000) was an integral part of many vital initiatives in Huntsville, including the American Association of University Women's Huntsville branch, the Huntsville Historic Foundation, and the University of Alabama in Huntsville. Roberts taught history at UAH before it became a university, and also taught classes at West Huntsville High School, which later became Butler High School and then Stone Middle School.

A teacher in the Huntsville public schools for 18 years, Roberts was the first woman to receive a PhD in history from the University of Alabama; she earned her doctorate while teaching classes at the University of Alabama Huntsville Center, later known as UAH. She directed UAH's Academic Advisement Center from 1972 until 1980, when she retired from teaching.

In addition to her role as a founding member of the University of Alabama in Huntsville, Roberts worked with architect Harvie Jones to establish the Old Town and Twickenham districts of downtown Huntsville and specified the parameters for the regulation of new construction and renovation within those districts. She also helped to establish the Weeden House Museum, Burritt Museum, and Constitution Village—all key pieces of Huntsville's past, and vital attractions of its present.

Roberts was inducted into the Alabama Women's Hall of Fame in 2013. (Both, courtesy of the Huntsville–Madison County Public Library Archives.)

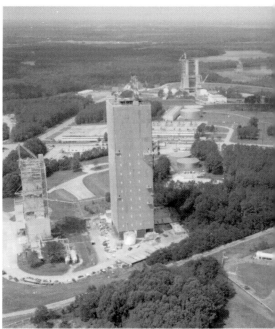

Ernst Stuhlinger

German-born rocket scientist Ernst Stuhlinger (1913–2008) served as the associate director of Marshall Space Flight Center from 1960 to 1975. He expressed interest in space exploration from a young age. After being part of Wernher von Braun's team in Peenemünde during World War II, Stuhlinger came to the United States through Fort Bliss, to New Mexico, and eventually to Huntsville, where he worked with von Braun in developing the Redstone, Jupiter, and Pershing missiles. His expertise in electrical propulsion won him the American Rocket Society's Propulsion Award in 1960.

Stuhlinger, a World War II scientist with a doctorate in physics, was an associate of Hans Geiger and was involved in the initial phases of the development of the Hubble Space Telescope. He helped in the planning of human lunar exploration, studied payloads for the Space Shuttle program, and was director of the Space Sciences laboratory.

One of Stuhlinger's more prominent contributions came in 1958, subsequent to the Russian surprise launch of *Sputnik* in October 1957. Without sufficient time for tests, Stuhlinger created a timing device from screws, wires, and nuts from his garage to launch a satellite into orbit. The timing of the trigger for the second-stage firing of the *Explorer I* satellite had to be just right. Stuhlinger used his homemade timing device to launch the satellite into orbit from Cape Canaveral on January 31, 1958. He became known as "the man with the golden finger."

Following his retirement from NASA in 1975, Stuhlinger taught astrophysics as an adjunct professor at the University of Alabama in Huntsville. He decried the Nazi era as "extremely deplorable," noting that, by the end of the war, his focus and that of his colleagues, including von Braun, had been not on war, but on space. He died at his home in Huntsville in May 2008. Pictured above right is the Marshall Space Flight Center Test Area. (Both, courtesy of the Huntsville–Madison County Public Library Archives.)

Miss Baker

Identified formally as "Miss Baker: First Lady in Space," this squirrel monkey traveled into space in the nose cone of a Jupiter ballistic missile in May 1959. Other than fruit flies, Miss Baker (1959–1984) and her companion, a rhesus monkey named Able, were the first US animals to fly in space and return alive; they were rescued from the nose cone in the water and flown to Washington, DC, for a press conference. Able passed away several days after their flight due to complications while having an electrode removed, but Miss Baker was sent to Huntsville, where she lived for 25 years, with her primary residence at the US Space & Rocket Center. She is buried there, and visitors often pay tribute by leaving bananas on her grave, located at the entrance to the museum. Shown at left is Miss Baker's partner, Able, in his apparatus for the space launch in 1959. (Above, courtesy of NASA, from the collection at the US Space & Rocket Center; left, courtesy of the Huntsville–Madison County Public Library Archives.)

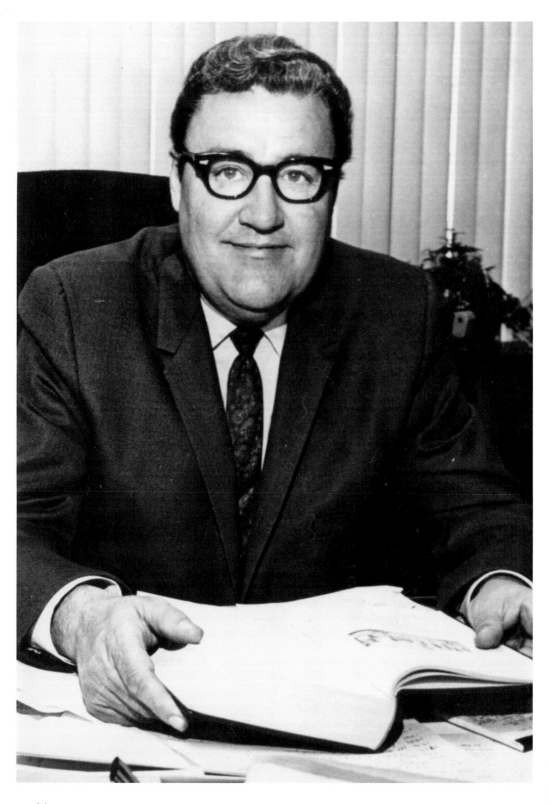

James Record (ABOVE AND OPPOSITE PAGE)
A historian and an Alabama state senator, James Record (1918–1996) served as chair of the Madison County Commission from 1962 to 1981. A World War II veteran of the US Army Air Corps, Record, born in New Market, sought to preserve and celebrate the history of Madison County by writing five volumes about its evolution. Prior to his death, he was able to finish two exhaustive volumes of *A Dream Come True: The Story of Madison County and Incidentally of Alabama and the United States.*

While he was chair, the commission established the Madison County Nature Trail on Green Mountain, as well as the Sharon Johnston Park in New Market. Record contributed to the establishment of the Huntsville International Airport and to other projects serving the county, including paved roads and garbage pickup. He was an integral part of the effort to bring UAH to full university status and helped raise funds for the establishment of the US Space & Rocket Center. The Madison County Hall of Heroes, still on view today at the Madison County Courthouse, was founded by Record in 1975.

Record served as president of numerous organizations in Madison County, including Burritt Museum, the Elks, the Veterans of Foreign Wars, the Madison County Health Department, the YMCA, and the American Legion. Record is second from left above. (Both, courtesy of the Huntsville–Madison County Public Library Archives.)

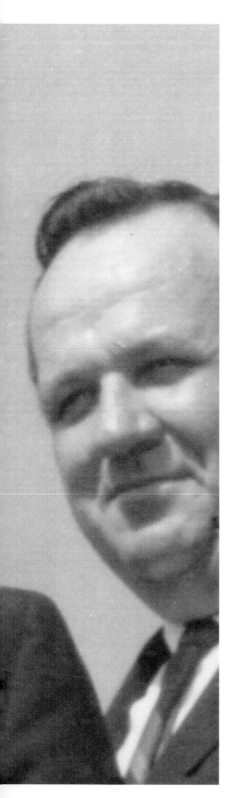

Ed Mitchell

In the early 1960s, when Ed Mitchell and the board of the Huntsville Airport Authority began to scout for land on which to relocate the small airport on Airport Road, their suggestion to move the facility out toward Decatur was met with skepticism. Mitchell chaired the Huntsville Airport Authority board from 1956 to 1968. The Port of Huntsville comprises the Huntsville International Airport (below), Jetplex Industrial Park, and the International Intermodal Center, which was Mitchell's vision for a hub that tied together air, rail, and highway transportation.

Mitchell (1918–2011) was also general manager of Ditto Landing Marina. He was instrumental in bringing to Madison County the I-565 spur from Interstate 65 and continued to envision other transportation achievements, such as high-speed rail and a super highway between Memphis and Atlanta.

Born in Madison County, Mitchell attended Marion Military Academy and Jones Law School. He served in the Air Force. For 20 years, he was a partner with Mitchell, Pearson, and Carpenter Insurance Adjustors. (Both, courtesy of the Huntsville–Madison County Public Library Archives.)

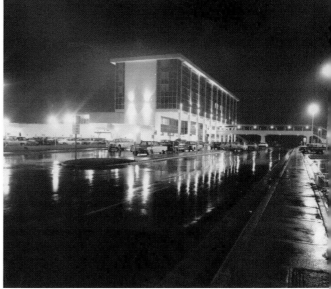

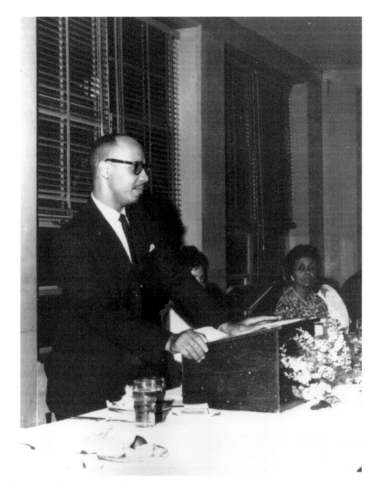

Sonnie Wellington Hereford III

The son of a preacher and the grandson of an enslaved sharecropper, Dr. Hereford (b. 1931) grew up attending the all-black Councill School in Huntsville. He attended Meharry Medical College in Nashville and opened his practice in Huntsville in 1956.

Hereford, a civil rights activist, faced many challenges during the height of segregation, both in his own career and as a parent. Along with several others, including Dr. John Cashin and Rev. Ezekiel Bell, he helped to form the Community Service Committee in 1962 for the primary purpose of bailing out students in order to maintain numbers for sit-ins. Hereford met Dr. Martin Luther King Jr. at the airport when he visited Huntsville that same year.

In 1962, Hereford entered a lawsuit in his son's name so that Sonnie Hereford IV could attend an all-white public school, the Fifth Avenue School, within yards of his home; the all-black school was over a mile and a half away. The judge said that *Brown vs. the Board of Education* did not apply to the case, and going against Gov. George Wallace's wishes, ruled in favor of Hereford attending the school. On September 9, 1963, Sonnie Hereford IV became the first black student to attend a white public school in Alabama.

Dr. Hereford delivered over 2,200 babies during his career. In 2016, the Sonnie Hereford Elementary School, named after Hereford and his son, will open in the Terry Heights community of Huntsville. Unlike Dr. Hereford's own elementary school experience, which involved attending a school seven miles away, surrounded by the city dump, lacking books, a playground, and library access, the new Sonnie Hereford Elementary will have a state-of-the-art library, computers, and two playgrounds. (Courtesy of the Huntsville–Madison County Public Library Archives.)

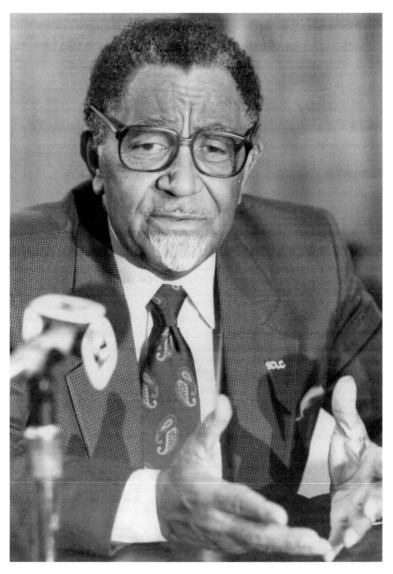

Joseph Lowery

Born and raised in Huntsville and subjected to racial discrimination as a child, Rev. Joseph Lowery (b. 1921) became a civil rights activist. His efforts continue to keep him in the forefront of civil rights today and have earned him the nickname, "the dean of the civil rights movement."

Lowery attended Knoxville College, Paine College, and Chicago Ecumenical Institute, where he graduated in 1950 with a PhD in divinity. He moved to Mobile to pastor a church there in 1952, and in 1957 joined with Dr. Martin Luther King Jr. and others to form the Southern Christian Leadership Conference, of which he eventually became the chair. He moved to Birmingham in 1964 to pastor a church, and in 1965 joined the march from Selma to Montgomery.

Lowery became president of the SCLC in 1977. His career eventually took him to a different church and on to Atlanta, where he retired in 1992. Lowery gave the benediction at the 2009 inauguration of Pres. Barack Obama. Clark Atlanta University established in his honor the Joseph E. Lowery Institute for Justice and Human Rights in 2001. (Courtesy of the Huntsville–Madison County Public Library Archives.)

The Present Future

Technology and the Arts

Industry in the city proper continued to grow, as individuals including Olin King, Julian Davidson, Jim Hudson, and Mark Smith established successful firms that eventually acquired national status. The rolling topography of Huntsville changed as farmland owned by the Joneses and the Goldsmiths, among others, became commercial property. Sports heroes and hall of famers emerged, Vietnam War POWs returned home, Huntsville City Schools gained an official physical education program, and the Huntsville Botanical Garden opened, bringing thousands of visitors to the city each year. Rep. Bud Cramer opened the National Children's Advocacy Center, which became a model and training center for children's advocacy centers around the world.

Huntsville natives and friends Gloria Batts and Bobby Bradley began to serve children in a different capacity through the establishment of the Village of Promise, gourmet cuisine became a staple of the city, and local high school graduates left their hometown to become world-renowned opera singers and to start the largest online encyclopedia. Harvie Jones strove to protect the architectural splendor of the city, and individuals like Debra and Alan Jenkins turned such places as Merrimack Mill into an acclaimed performing-arts center whose programs serve hundreds of children in the Huntsville community. Lowe Mill Arts and Entertainment, another converted mill, is an additional draw to the city, bringing thousands from all over the country. Lowe Mill is the largest arts center in the southeastern United States; it recently added an additional wing to its facility, along with 200 more artists.

Huntsville's mayors have continued with the same pioneering spirit as its first leaders, laying down millions of dollars' worth of roads, expanding downtown Huntsville, bringing jobs to the city, and expanding Cummings Research Park to the point that it is the second-largest technology research park in the country.

Fantasy and Fantasy Jr.
Sarah Mitchell ("Fantasy") and Penelope Shickles ("Fantasy Jr.") open each Fantasy Playhouse performance, welcoming the audience and offering background information on the show. The playhouse has been a part of the Huntsville community since 1961, bringing theater arts to the children of Huntsville and North Alabama. It has enjoyed and benefited from the expert direction and contribution of such locals as Helen Herriott and Loyd Tygett. (Courtesy of Fantasy Playhouse Children's Theater and Academy.)

Lowe Mill Arts and Entertainment
Since the early 2000s, Lowe Mill Arts and Entertainment has drawn locals and visitors from all over the world to enjoy its eclectic mix of arts, music, theater, and other forms of expression. The conception and design of Jim Hudson, who purchased the former shoe factory in 2001, Lowe Mill opened another wing in late 2014, introducing 31 additional studios to the largest arts center of its kind in the Southeast. (Photograph by the author.)

Eunice Merrill

Anyone who ever had the opportunity to eat at Eunice's Country Kitchen knew that customers could get sorghum syrup if requested, were expected to know how to pour coffee for anyone who needed it, and were likely to leave with a hug from Aunt Eunice herself.

Eunice Merrill (1919–2004), known affectionately and universally as "Aunt Eunice," was no stranger to pitching in when necessary. One of 12 children, Aunt Eunice was the daughter of a minister who grew up accustomed to doing a number of chores, and she traded her school lunch ham and biscuits for peanut-butter sandwiches when she had the chance. Shortly after she married in 1940, she began working at her brother-in-law's restaurant, where she learned what she believed to be two fundamentals of running a restaurant: how to pour coffee and how to keep her mouth shut.

When she opened Eunice's Country Kitchen in 1952, Eunice Merrill already had a loyal following, as she had owned Butler Grill, across from Butler High School, for several years. Aunt Eunice specialized in country ham and biscuits; Gov. Fob James named her biscuit the official biscuit of the state of Alabama.

In addition to her restaurant, she was very active in the community, particularly with the Arthritis Foundation. When she was brutally attacked and robbed in October 1995, her fierce loyalty both to the foundation and to her patrons helped her return to the restaurant right after her release from the hospital. She participated in a fundraiser for the foundation just days after the attack.

Eunice's Country Kitchen was a nondescript brick building that one would likely miss if not looking for it. Inside, the walls were adorned with signed photographs of those who had eaten there—sports legends, movie stars, and astronauts. Politicians could be found at the "Liar's Table," marked with a sign, in the center of the restaurant, often reserved for "Politishins and Fisherfolk." After the restaurant closed, the modest brick building with the gravel lot was razed. Many of the restaurant's contents, along with its locally famous "Country Ham" sign, are preserved at the Huntsville Depot and Museum, including some tables, covered benches, the cash register, autographed photographs, and the coffee pot. Aunt Eunice died in 2004. (Courtesy of the Huntsville–Madison County Public Library Archives.)

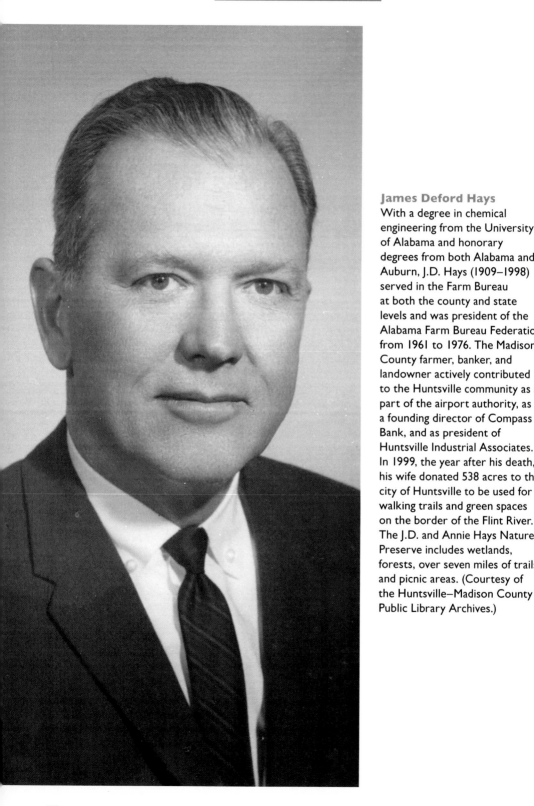

James Deford Hays
With a degree in chemical engineering from the University of Alabama and honorary degrees from both Alabama and Auburn, J.D. Hays (1909–1998) served in the Farm Bureau at both the county and state levels and was president of the Alabama Farm Bureau Federation from 1961 to 1976. The Madison County farmer, banker, and landowner actively contributed to the Huntsville community as a part of the airport authority, as a founding director of Compass Bank, and as president of Huntsville Industrial Associates. In 1999, the year after his death, his wife donated 538 acres to the city of Huntsville to be used for walking trails and green spaces on the border of the Flint River. The J.D. and Annie Hays Nature Preserve includes wetlands, forests, over seven miles of trails, and picnic areas. (Courtesy of the Huntsville–Madison County Public Library Archives.)

Olin King

The first member of his family ever to be outside of Georgia for more than 48 hours, Olin King (1934–2012) founded Space Craft Inc., later known as SCI, in his garage in 1961 with two partners and $21,000. The Fortune 500 company eventually had over $1 billion in revenue and more than 24,000 employees around the world.

King, who earned a bachelor's degree in physics from North Georgia College, served as an Army Signal Corps officer in South Korea for two years, and worked for RCA and the Army's ballistic missile program building satellites. After President Eisenhower shut down the satellite program, King sought to design and sell satellites to private buyers. He later diversified his company into commercial activities and was able to continue to thrive by getting military aircraft and government aerospace contracts; King is famously credited with creating the contract manufacturing industry in the United States. SCI went on to work with IBM and was, at one point, its largest supplier. King retired as CEO of SCI in 1999 and stepped down as chairman in 2001. Sanmina bought SCI in 2001 for a reported $6 billion. King, inducted into the Alabama Business Hall of Fame in 2000, died in 2012. (Courtesy of the Huntsville–Madison County Public Library Archives.)

Helen Moore Herriott

Although she had only a little experience as an actress, Helen Herriott's name came to be synonymous with successful children's theater in Huntsville beginning in the late 1960s, and remains so today. A native of Wisconsin, Herriott was a secretary when she met her future husband, Jim, an engineer, who worked on such projects as the Chicago subway and the Hoover Dam. Shortly after they married, the young couple moved to Illinois, then to Seattle, where Jim worked with Boeing. He was transferred to Huntsville in the late 1960s and helped build the Saturn V.

Fantasy Playhouse Children's Theater had come about in 1961, and Herriott began directing shows for Fantasy. Her endeavors eventually morphed into a year-round program of theater instruction for children. Herriott helped her young actors to emote, project, and articulate, and never to peek outside the curtain. An exceptionally expressive instructor, she taught her students traits useful not only for acting, but also for life: to be responsible for their props, their lines, and their roles, and to carry themselves in a proper manner.

Herriott worked tirelessly for the playhouse, working with students for hours on their performances. She often wrote parts for Panoply's Showcase of the Arts and was a master of improvisation.

Now in its 54th season of supporting excellence in children's theater, Fantasy Playhouse continues to produce beloved shows for the community. Fantasy offers the Herriott Scholastic Scholarship, in honor of Herriott and her husband, to a high school senior who has exhibited excellence in performance and to a student who embodies the spirit of imagination and of perseverance, commitment, and hard work. (Courtesy of the Huntsville–Madison County Public Library Archives.)

Virginia Hammill Simms

In 1965, Simms (1907–1966) went to Arts Council director Erik Fris with a request to bring all of the performing arts organizations in Huntsville together for a production; thus, the Showcase of the Arts was born, featuring all the organizations of the Arts Council. Following her death in 1966, the board of the Community Ballet Association sought to honor Simms's example of volunteer spirit and commitment to the arts by granting an award in her memory. The award, given annually, acknowledges a member of the community who, like Simms, exemplifies volunteerism in contribution to the arts. Past recipients include Harvie Jones, Loretta Spencer, Debra Jenkins, and Ron Harris. (Courtesy of Nancy Noblitt.)

Glenn Hearn

Before he was mayor of Huntsville, Hearn (1914–1975) was the senior agent at the head of the FBI in North Alabama for all but three years of his service with the agency. During Hearn's mayoral term (1964–1968), the city of Huntsville grew by almost 40 percent. In 1966, along with the mayors of Detroit, Omaha, St. Louis, and Phoenix, Hearn served on a panel to discuss New York City mayor John Lindsay's creation of the New York City Police Review Board; Hearn cited Huntsville's massive growth rate as one of the biggest problems the city faced. Hearn did not run for a second term right away, and his administrative assistant, Joe Davis, became his successor. Hearn served in the state legislature from 1970 until 1974 and was the Madison County personnel director at the time of his death. (Courtesy of the Huntsville–Madison County Public Library Archives.)

Erik Fris

Erik Fris, executive director of the Arts Council, is standing in the back in this photograph from *The Huntsville Times* of Sunday, March 12, 1967. Fris was part of the group that coordinated the first Showcase of the Arts in the late 1960s, an event that highlighted the performing members of the Arts Council. Along with representatives of other arts organizations, including Community Ballet, the Civic Opera Society, the Civic Symphony, Fantasy Playhouse, and the Film Forum, Fris advocated for the availability of resources and tools to artists, a mission the Arts Council adheres to today. Fris was an arts ambassador in other parts of the country, representing Huntsville at the National Convention of the American Symphony Orchestra League and the Community Arts Council Inc. in Detroit in 1964. Closer to home, he spoke in 1968 to a group of citizens interested in forming the Shoals Arts Council, lauding Huntsville's successful efforts to create a central point of contact for arts activities. Today, the Arts Council continues its mission of supporting arts in the community and provides resources, workshops, and centralized information. It is the administrator for the city's Arts and Cultural Grant program. The Arts Council has over 250 active members, including both individuals and organizations. (Courtesy of Fantasy Playhouse.)

Raymond B. Jones

Ray Jones was a little boy when his father, Carl, bought a 2,500-acre farm just south of Huntsville in 1939. The city's population at the time was 12,000. His dad's intentions were to revive the family engineering business; if the business did not succeed, the family could fall back on farming. Today, Jones Valley Farm is a large, active farm in the middle of the city and a gorgeous oasis of green. It is one of the largest operating urban farms in the country.

Jones worked in farming and in real estate and became the president of G.W. Jones & Sons Consulting Engineers Inc. upon his father's death in 1967. After serving as president for 35 years, Jones continued his involvement with the company as CEO. G.W. Jones was acquired by Littlejohn in 2013.

Jones graduated from Huntsville High School (1953) and from Auburn University (1957), after which he served as a second lieutenant with the National Guard in the Corps of Engineers. He returned to the farm in the late 1950s. His other community and civic involvement has included serving as director of First National Bank in Huntsville, and as president of Huntsville Industrial Associates, the Huntsville Hilton Corporation, the North Alabama Mineral Development Company, the Huntsville Rotary Club, and others. He received the Madison County Chamber of Commerce Distinguished Service Award in 2002. Jones's history of the family farm, *The Farm in Jones Valley*, was published in 2007. He is pictured here (center) with his parents. (Courtesy of the Huntsville–Madison County Public Library.)

Jane Knight Lowe (BELOW AND OPPOSITE PAGE)

During her lifetime, Jane Knight Lowe (1902–1997) made numerous contributions of her time and talents to a number of organizations in the Huntsville community. A philanthropist and civic leader, Lowe was one of the founders of Randolph School in 1959 and a lifetime member of its board of trustees. She had a particular interest in education, specifically the University of Alabama at Birmingham's research on arthritis, an affliction from which she suffered. She supported the Huntsville–Madison County Public Library, serving on its board for 40 years, including as board chair (1967–1971). Lowe contributed to the YMCA and anonymously to a number of other civic organizations.

Following her death and in accordance with her will, the Jane K. Lowe Charitable Foundation was established in 1997, and Lowe's residence was donated to the University of Alabama Huntsville Foundation. Her will established a Jane K. Lowe Chair of Medicine in Rheumatology at UAB, and her foundation named a number of organizations to benefit from 60 percent of the foundation's assets over the course of 30 years, including UAB, Randolph School, Huntsville Boys Club Trust and Endowment Fund, and Girls Incorporated. The other 40 percent of the assets is distributed annually to local organizations at the discretion of the foundation's board of trustees. Lowe is pictured third from right on the opposite page. (Both, courtesy of the Jane K. Lowe Foundation.)

Harry Townes
Born in Huntsville, Townes (1914–2001) studied acting at Columbia University and went on to perform in Broadway shows, such as *Tobacco Road* and *Twelfth Night*, and in over 15 movies, including *Sanctuary* and *The Brothers Karamazov*. He made television appearances on such shows as *Star Trek*, *The Twilight Zone*, *Perry Mason*, *Gunsmoke*, and *Knots Landing*. Townes became an ordained Episcopal priest in 1974 and eventually returned to his hometown of Huntsville. He is buried in Maple Hill Cemetery. (Courtesy of Deborah Thomas.)

Loyd Tygett

Tygett (1921–2002) joined Community Ballet School and the Huntsville Civic Ballet Company in 1964 as its artistic director. Tygett was a theater legend, choreographer, and artist who had previously danced with the Chicago Opera Ballet, the London Ballet, and the American Festival Ballet. During his tenure at Community Ballet, he painted over 60 backdrops for the company.

Tygett worked closely with Fantasy Playhouse's Helen Herriott, and the company performed its first show, *Cinderella*, in December 1965 with the playhouse. He choreographed many shows for the playhouse as well as for the Community Chorus. Community Ballet performed *Swan Lake*, its first ballet as a company, in April 1967 under the direction of Tygett and with guest artists from the Royal Winnipeg Ballet of Canada and the New York City Ballet.

In addition to his background in dance, drama, and set design, Tygett composed original ballets, including *The Comedians*, which he choreographed to the music of Dmitri Kabalevsky. Tygett led the company to membership in the South Eastern Regional Ballet Association (SERBA) in 1967. While at Community Ballet until his retirement in 1997, the company grew steadily, from an average of 150 students in 1970–1971 to over 600 by the 1997–1998 school year. Community Ballet School toured all over the northern part of the state and had branch schools in some locations, including in Boaz and Athens. The mayor of Huntsville named April 13, 1996, Loyd B. Tygett Day. (Both, courtesy of Linda Soulé.)

Mark C. Smith

A native of Birmingham, technology icon Mark Smith (1940–2007) first expressed his scientific and technological acumen in high school, when his science teacher encouraged him to enter the University of Alabama at Birmingham science fair. Smith entered a light-beam timer and won; his award was to meet Wernher von Braun. Smith went on to study electrical engineering at the Georgia Institute of Technology and began working at SCI in Huntsville shortly after graduating.

In 1969, at the age of 29, Smith invested his life savings into his own business venture, Universal Data Systems, a modem company and Alabama's first data communications company. He sold the company to Motorola in 1978. Less than 10 years later, Smith partnered with Lonnie McMillian to found Adtran, a worldwide networking and communications company. The first product Adtran created allowed a telephone company to send data to a business over a private line. Smith served as CEO of Adtran and retired from the company in 2005, by which point the start-up of seven employees had grown to over 1,700. Adtran still thrives today in the forefront of its industry.

In addition to his technological expertise, Smith was regarded for his humility, incredible generosity, and integrity, and was actively involved in his community through such civic organizations as the Rotary, the Huntsville Symphony Orchestra board, and the board of the HudsonAlpha Institute for Biotechnology. Smith was also on the building committee for HudsonAlpha and was on its founding board. He achieved many honors, including an honorary science PhD from the University of Alabama in Huntsville, a place in the State of Alabama Engineering Hall of Fame, CEO of the year 2000 from the *Birmingham News*, and the first recipient of the Alabama Information Technology Association Lifetime Achievement Award. (Courtesy of Linda Smith.)

Don Mincher
The only major leaguer to play for both incarnations of the Washington Senators, Don Mincher (1938–2012), first baseman and left handed hitter, was a 13-year veteran of the major leagues. In addition to playing for the Minnesota Twins—including in the 1965 World Series against the Los Angeles Dodgers—Mincher played with the Texas Rangers, the Seattle Pilots, and the California Angels. He was with the Oakland A's in the 1972 World Series against the Cincinnati Reds. His pinch-hit RBI single helped Oakland win the fourth game of the series.

Following his retirement from the major leagues, Mincher returned to his hometown of Huntsville and eventually became the general manager of, broadcaster for, and owner of Huntsville's own AA team, the Huntsville Stars. He served as president of the Southern League from 2000 to 2011. (Courtesy of the Huntsville–Madison County Public Library Archives.)

Harvie Jones (ABOVE AND OPPOSITE PAGE)

An award-winning preservationist for over 600 projects in the Southeast, with a number of those in Savannah, Georgia, architect Harvie Jones (1930–1998) salvaged and restored numerous historical structures in Huntsville and, along with them, pieces of local history. By the early 1970s, when he began work on the restoration and design of Alabama's Constitution Hall Village, Jones had become active in preservation. His projects included buildings at Burritt, the Weeden House, the Annie C. Merts Center, the Huntsville Depot, and numerous residential structures downtown.

Jones developed a technique in which he used a computer to enhance historical photographs so he could examine minute details of structures in order to restore them to their original design. He served on the board of *Alabama Heritage* magazine and helped establish the Twickenham Historic District. Jones also helped found the Historic Huntsville Foundation. He was an original member of the Huntsville Historic Preservation Commission, serving on its board from its inception in 1972 until his death. Additionally, he served on the Twickenham Historic Preservation District Association, the Arts Council, and the Huntsville Art League and Museum Association. He is remembered by many as a fine member of the Huntsville community who was always walking—to work, to home—always observing, sometimes with a camera, always with preservation and architectural integrity in mind. (Both, courtesy of the Huntsville–Madison County Public Library Archives.)

Mike Christian

Born and raised in Huntsville, Mike Christian (1940–1983) graduated from Butler High School and enlisted in the Navy. In April 1967, his plane was shot down in North Vietnam, and he was immediately captured. His family heard nothing from him until 1970, when they began to receive letters alerting them to his survival.

While a prisoner of war, Christian gathered scraps of fabric from his fellow prisoners, including John McCain, fashioned a needle out of bamboo, and, on the inside of his shirt, sewed together an American flag, which he and his fellow prisoners saluted each day, and in the presence of which they said the Pledge of Allegiance. His wardens eventually discovered the flag, destroyed it, and beat him; this did not keep him from beginning to sew another flag.

Christian was released in March 1973. The City of Huntsville threw a celebration in his honor on his return home, and April 7, 1973, was declared Mike Christian Day. For his service, Christian was awarded two Bronze Stars, two Silver Stars, two Purple Hearts, and a Legion of Merit award. (Both, courtesy of the Huntsville–Madison County Public Library Archives.)

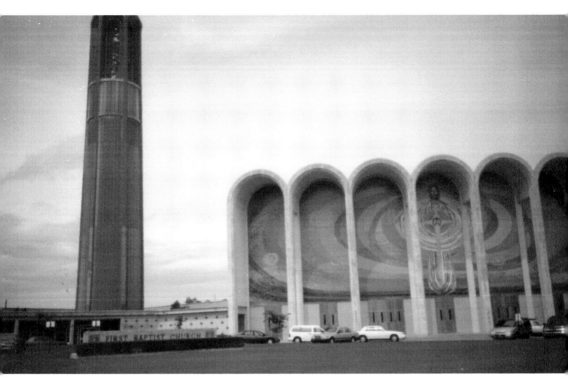

"Eggbeater Jesus"

Standing 43 feet high, with a head that is five feet high and eyes that are eight inches in diameter, the Christ mosaic at First Baptist Church on Governors Drive presides majestically as an unavoidable focal point for motorists, pedestrians, and other passersby going east through the Medical District. Affectionately referred to by locals as "Eggbeater Jesus," the mosaic creates a sense of motion, with parabolas, colors, and symbols swirling around the solid and serene depiction of Christ.

Artist Gordon Smith of Smith Stained Glass worked on the mosaic from 1966 to 1973, setting in place, either by hand or with tweezers, over 14 million pieces of Italian tile, each no bigger than a thumbnail. The image as a whole depicts a theme of creation and redemption, of order evolving out of disorder, and is inspired by Revelation 1:12-20, a passage vividly describing seven golden candlesticks (symbolizing seven churches), Christ with hair white like wool and snow, with seven stars in his right hand, and a two-edged sword coming from his mouth, symbolizing the word of God.

Visually, the perspective lines converge on a mysterious horizon, inextricably interwoven in a sea of sound and color, pulling all galaxies into its orbit. The Christ figure is at the center of the universe, forever moving and representing all of the time-space continuum while concurrently inviting people into the church. Just beyond the mosaic rises the church's 229-foot zinc alloy–covered steeple, which houses a 48-bell carillon that can be heard throughout the Medical District at various times during the day. (Courtesy of the Huntsville–Madison County Public Library Archives.)

Gene McLain

A native of Clay County in mideastern Alabama, state senator and land developer Gene McLain (1931–2001) attended Auburn University on a Sears Roebuck Merit Scholarship and then studied economics in Cambridge, England, on a Rotary Foundation fellowship. After serving two years in the Air Force, McLain attended the University of Alabama School of Law and began to practice law in Huntsville following graduation.

McLain, a member of the state house of representatives who easily defeated his incumbent opponent in the 1970 state senate race, ran for governor against George Wallace in 1974. Among a number of issues McLain sought to rectify were the current state of mental hospitals, the prison system, the interstate highway system, and education.

McLain was an integral part of the commercial development of Huntsville in the 1970s, 1980s, and 1990s. He formed Coldwell Banker Commercial McLain Real Estate in 1974. He owned and developed a number of properties in Huntsville, including the former site of the Heart of Huntsville Mall and Lowe Mill, which he bought in 1990 and sold to Jim Hudson in 2001. (Courtesy of the Huntsville–Madison County Public Library Archives.)

John Stallworth

Inducted into the Pro Football Hall of Fame in 2002, John Stallworth (b. 1952) attended Alabama A&M University from 1970 to 1974, where he held the school's record as the all-time leading receiver. He graduated with a bachelor's degree in business administration and went on to earn an MBA with a finance concentration, also at A&M.

In 1974, Stallworth was selected by the Pittsburgh Steelers in the fourth round of the NFL draft. He played 14 seasons, setting records for passes caught, yards gained, and touchdowns scored. He played in four Super Bowls and six AFC championships, and was named All Pro in 1979 and All AFC in 1979 and 1984.

In 1986, he formed Madison Research Corporation, which was named one of the 500 fastest growing small businesses by *Inc.* magazine and was ranked No. 11 among the top 25 small minority and technology companies in the nation.

Stallworth retired from professional football in 1988. He remains active in the Huntsville community today, is a partner in Genesis II, a business in support of philanthropic efforts and investments, and serves on various boards, including as chair of the board of directors of the John Stallworth Foundation, an initiative that provides scholarships for students at A&M. (Courtesy of the Huntsville–Madison County Public Library Archives.)

Joe Davis

As NASA's Apollo program came to a close in the 1970s, Huntsville needed strong leadership. Joe Davis (1918–1992), a former teacher and real estate businessman who served five consecutive mayoral terms between 1968 and 1988, provided this leadership. During his time as mayor, the city added over 45,000 industrial jobs. Mayor Davis maintained a strong relationship between the city and the military and Redstone Arsenal.

Major developments under Mayor Davis's leadership include the construction and erection of the Von Braun Civic Center in 1975, the current Huntsville–Madison County Public Library in 1987, the construction of Joe Davis Stadium ("the Crown Jewel of the Southern League") in 1985, and the commencement of I-565, the spur connector to Interstate 65, in the late 1980s. Additionally, Davis helped to fund a solid waste incineration plant and helped develop Research Park. He won an award for top mayor in the United States in 1975. Davis is buried in Maple Hill Cemetery. (Courtesy of the Huntsville–Madison County Public Library Archives.)

D. Scott McLain

The son of prominent parents Gene McLain, former state legislator, and Jerri McLain, former hospital administrator and community leader, D. Scott McLain (b. 1956) has been involved in the development and promotion of Huntsville since an early age. He graduated from Huntsville High School in 1974 and earned his degree in public policy from Duke University. He went on to earn his law degree from Cumberland School of Law in 1981. In 2007, he did postgraduate work in the Advanced Management Development Program in Real Estate at Harvard University's Graduate School of Design.

A former lawyer, McLain is currently a broker, manager, and developer of commercial real estate in the region, including a major live-work-shop development in downtown Huntsville. He has used and continues to use his experience and education to contribute to the success of the Huntsville community. McLain has served on over 60 community, state, and national boards. (Courtesy of D. Scott McLain.)

Fred B. Simpson

Known to be a passionate force in the courtroom, Fred Simpson (1937–2014) grew up in Calera, Alabama, and joined the Air Force at the age of 16. He graduated from Howard College, now Samford University, which he attended during the day while working as a police officer at night in order to put himself through school. Simpson met his future wife at this time, and upon graduation, the young couple moved to Nashville, where he attended Vanderbilt University Law School.

Simpson's law practice brought him to Huntsville in 1964, and following a one-year assignment with Redstone Arsenal and four years in a private firm, he was appointed district attorney of Madison County in 1969, a position he held until 1981. As a prosecutor, he tried 64 murder cases. He played an integral part in getting state laws on the books against child abuse and drunk driving. Following his retirement as district attorney, Simpson practiced law for another 25 years, practicing criminal law specifically. In 2002, he was recognized for outstanding legal representation by the Alabama Criminal Defense Lawyers Association.

In addition to his reputation as a fine attorney, Simpson authored several books about Huntsville history, lynchings on the square, laws, and murder cases, including a pictorial history of downtown Huntsville. Simpson was a fervent advocate for the development of downtown Huntsville, served on the downtown development board, and was instrumental in passing ordinances to allow outdoor cafés. He was a prolific painter as well, a talent to which he applied his lifelong interest in learning and in which he maintained his passionate dedication. Simpson is buried in Maple Hill Cemetery. (Courtesy of the Huntsville–Madison County Public Library Archives.)

Mary Jane Caylor
A native of Huntsville educated in Huntsville city schools, and a graduate of the University of Alabama, Dr. Caylor has taught at East Clinton Elementary School and at UAH, Alabama A&M, and Athens College. She served as superintendent of Huntsville City Schools from 1982 to 1991 and then served four terms on the state board of education from 1995 to 2011. She was named Superintendent of the Year by the Alabama Council of PTAs in 1990 and is a charter member of Leadership Alabama. Caylor established the Huntsville City Schools Foundation in 1991; the foundation joined with the Madison County Schools Foundation in 2000 to create The Schools Foundation, an organization that today successfully serves all three public school systems in Madison County. (Both, courtesy of the Huntsville–Madison County Public Library Archives.)

MARY JANE CAYLOR
SUPERINTENDENT

MRS. M.

Bill Holbrook

When he was a child, Bill Holbrook (b. 1958) and his family moved from Los Angeles to Huntsville when his father took a job with the space program. Bill's father, who worked at a technical testing firm, would bring home big pieces of paper on which Bill could draw. Bill kept his classmates and teachers entertained with his doodles during class, and he drew for his high school newspaper. He studied illustration and visual design at Auburn University, and his drawings appeared in Auburn's student newspaper as well. Holbrook's editorial cartoons appeared often in the *Huntsville Times*. After graduating from Auburn in 1980, he took a job with *The Atlanta Constitution*.

In 1982, Holbrook met Charles Schulz, creator of the comic strip *Peanuts*. Schulz encouraged Bill to see what worked and what did not, rather than try to create the next big thing. This inspired Holbrook to create a comic about a college graduate struggling in a dead-end job at a diner. His persistence with that strip, and the merger of *The Atlanta Constitution* and *The Atlanta Journal* in 1982, gave Holbrook years of material for his hit comic strip *On the Fastrack*, which debuted in 1984 and still runs today, primarily online. A prolific artist, Holbrook has two other daily strips, *Safe Havens* and *Kevin and Kell*; he has published a graphic novel of the latter. Holbrook stated in a 2001 interview that he continually draws on his techie background as a Huntsville native, and bases many of his techie characters on friends he had from his hometown in Alabama. (Courtesy of the Huntsville–Madison County Public Library Archives.)

Doris McHugh

When Doris McHugh (b. 1934) earned her bachelor's degree from the University of Alabama in 1955, there was no degree in physical education. After teaching in Louisiana, Colorado, and Tuscaloosa, McHugh became involved in the Huntsville City Schools system in 1960. By 1971, she had established the first formal physical education program for children in the Huntsville City Schools system.

In addition to writing the curriculum, hiring the personnel, and training the teachers in a physical education program that has been modeled throughout the country, McHugh opened 20 multipurpose rooms in Huntsville schools in 1983 in order to ensure that all schools had a place to teach physical fitness. She also implemented and directed the first Special Olympics for the city of Huntsville in 1969 and served as district director for that program for 10 years, then as area director. McHugh served as supervisor of physical education for K-12 in Huntsville City Schools for 17 years and then as HCS manager of special activities until 1996. Her passion for teaching has not been limited to primary and secondary school; she taught elementary classroom education as an adjunct professor at the University of Alabama in Huntsville for over 18 years.

McHugh spoke at the first National Conference for Physical Fitness and Sports, established by Pres. Jimmy Carter; has consulted on physical education and fitness nationally for the state departments of education in Alabama, Mississippi, Florida, and Texas; and helped develop Fitnessgram, the first nationwide program for computerized fitness scores. Her community involvement has included serving on the boards of the Harris Home for Children, the American Red Cross, Aid for Retarded Children, the Land Trust, and National Youth Sports Programs. Her numerous honors include the Governor's Award for Physical Fitness, Distinguished Alumna of the University of Alabama, one of the Top 31 Female Graduates in the Past 100 Years at the University of Alabama, and the Healthy American Fitness Leadership award, bestowed upon only 10 people nationwide. McHugh was a torchbearer in the 1996 summer Olympics. (Courtesy of the Huntsville–Madison County Public Library Archives.)

Sheryll Cashin
At four months old, Sheryll Cashin sat in her mother's lap at the Walgreens lunch counter on Washington Street during a sit-in. Her father, John Cashin, was also a political activist who ran for mayor of Huntsville in 1964 and for governor of Alabama in 1970; he was among the first black candidates on the ballot in the mayoral race.

Cashin graduated Butler High School in 1980 and went on to earn a bachelor's degree in electrical engineering from Vanderbilt, a master's degree in English law from Oxford, and a law degree from Harvard. She worked with Pres. Bill Clinton as an advisor on urban and economic policy and was a clerk to Supreme Court justice Thurgood Marshall. She has written several books on race relations, government, and inequality in America, and has been nominated twice for the Hurston/Wright Legacy Award for nonfiction. Her commentaries have appeared in the *Los Angeles Times* and *The Washington Post*, and she has appeared on numerous news programs and on NPR's *All Things Considered*. Cashin is a professor of law at Georgetown University. (Courtesy of the Huntsville–Madison County Public Library Archives.)

Ron Harris

From musicals to the theater of the absurd, from a small budget film about a postapocalyptic world to a play in which all the cast were dressed in red, for Ron Harris (b. 1945), the number-one thing has always been the story. "Remember," he says, "it's not you in the play, it's the play in you."

Born in Marengo County, Harris attended the University of Montevallo and graduated in 1967 with a degree in biology. He attended graduate school at the University of Georgia, where he earned degrees in psychology and botany and a master's degree in education. He moved to Huntsville in 1977 and taught at Ed White for one year, until Johnson High School opened in 1972. Harris also taught at Montevallo, where he earned a master's in speech therapy. He continued to teach at Johnson until 1986, when Lee High School's Performing Arts Magnet Program opened. For a while, Harris taught half a day of drama at the magnet program and half a day of English at Johnson; he eventually made the transition in 1988 to full-time drama teacher.

Harris and his students traveled to many festivals and competitions, winning awards all over the country. They opened the international Thespian Festival in Muncie, Indiana, and competed in the category of one-acts at the Trumbauer Secondary Theatre Festival, a true honor for Harris, who studied with Walter Trumbauer at Montevallo in the 1960s. Harris and his students traveled to the Southeastern Theater Conference in Miami, where they won first place with their performance of Eugène Ionesco's *The Chairs*. They won state with *The Serpent* and were chosen the best chorus/ensemble in the Carolinas.

Though he retired from teaching in 2005, Harris remains active in the local theater community, directing, coaching students, and acting. He is the recipient of the Marion Gallaway Lifetime Achievement Award for Alabama Theater (2000) and the Virginia Hamill Simms Award (2008), which recognizes an individual's contribution to the arts in the community. He adapted his original play *Like Moles, Like Rats*, into a film, *20 Years After*, in 2008. His acclaimed and compelling memoir, *Mr. Boy: Tales of a Southern Gentleman*, was published in 2011. (Courtesy of Merrimack Hall, photograph by Jeff White.)

Jim Hudson

From the time he got a chemistry set at the age of 10, Jim Hudson (b. 1942) knew he wanted to be a mad scientist. Born in Charleston, South Carolina, Hudson and his family moved to Huntsville from Chattanooga. After high school, he earned bachelor's degrees in chemistry and physics at the University of Alabama and went on to graduate school. During the Vietnam War, he was drafted into the Army. When he returned home, Hudson joined his father, who owned a foundry business, where he worked from 1970 until 1982.

When Herbert Boyer and Stanley Cohen discovered genetic engineering in 1974, Hudson became particularly interested in the field. His family sold the foundry in the early 1980s, and Hudson went back to school to UAH to study molecular biology for the sole purpose of finding a business opportunity. He had loved being in business, going from sweeping the floor at the foundry to being chief operating officer.

At that time, genetic sequencing required a synthetic piece of DNA, which took 30 days to get. Hudson met a woman who was selling a machine that could make four pieces in four hours. The machine, which had previously cost $50,000, was now only $25,000. Hudson bought it with the money he had been saving to start a business. His goal was to deliver custom-made DNA by the next day. He bought four machines and quickly took over the world market. In 1987, he founded Research Genetics. Hudson's business involved selling tools and resources to academics at cost. The company played a major role in the Human Genome Project. (Courtesy of Jim Hudson.)

Research Pioneer

Jim Hudson sold Research Genetics in 2000. In 2005, he joined with Lonnie McMillian, who helped found ADTRAN, to create the HudsonAlpha Institute of Biotechnology, a nonprofit biotech firm committed to genomic research, educational outreach, and economic development. HudsonAlpha opened its doors in 2008. Half of the institute's physical plant is devoted to genomics research, and the other half is rented to biotech companies. The institute has a strong mission of creating and developing companies to stay in Huntsville. It is one of the five largest genome centers in the country, and is one of the 10 largest in the world.

Hudson, who travels quite a bit, considers Huntsville home, and his commitment to the city is evident in other endeavors, including Lowe Mill Arts and Entertainment, the largest arts center in the Southeast. Hudson was inspired to create the center when he was living in Arlington, Virginia, in the late 1970s and regularly visited the Torpedo Factory Arts Center. He purchased Lowe Mill in 2001, formerly home to the Genesco Shoe Factory, which manufactured, among other things, combat boots for soldiers during the Vietnam War. The arts center continues to expand into all corners of the gigantic structure, has over 100 artists, and offers dining options, films, poetry readings, yoga classes, live concerts, and much more. Thousands from all over the country visit the mill on a weekly basis. Pictured here is the Summer Arts Stroll at Lowe Mill Arts and Entertainment. (Photograph by the author.)

Harvey Cotten

Interested in horticulture since the age of 14, Harvey Cotten (b. 1957) crafted a landscaping and loading job at Chase Garden Center into the fulfillment of a personal passion that ultimately benefited an entire community. Born and raised in Huntsville, Cotten found interest in the nursery side of his summer job at Chase Garden Center and participated in a work-study program every afternoon as a student at Huntsville High School. He attended Sewanee University for two years with a concentration in forestry and transferred to Mississippi State, where he graduated with a degree in ornamental horticulture. His experience, knowledge, and sense of wonder led him to travel to many nurseries, and in 1980, he managed the gardens and grounds at the historic Monmouth Plantation in Natchez, Mississippi. Cotten was an integral part of restoring and recreating the period landscape of the 1818 antebellum estate.

Cotten returned to Huntsville in 1986 with his new bride and child and began again to work for Chase. The committee behind the Huntsville Botanical Garden project had just begun to acquire land at that time, and in 1988, Cotten joined the effort as a volunteer. He joined the garden's board of directors in 1989 and went on staff as its executive director in 1992. He retired from the garden in 2014 as its vice president and chief horticulturist. In the many years in which he was involved, Cotten taught horticultural education, focused on developing the garden, worked with the Master Gardeners of North Alabama, and worked with the A&M plant sciences program. He also collaborated with HudsonAlpha on DNA sequencing of Alabama native plants.

Noting the botanical garden's humble beginnings as a grassroots effort, Cotten recalls that its development was a volunteer response to a community need. "People believe it's *their* garden," he says. With between 1,800 and 2,000 volunteers, the Huntsville Botanical Garden has one of the largest volunteer forces of any botanical garden in the country. "Huntsville is a place where people enjoy participating," says Cotten.

Cotten has served as the president of a number of other horticultural organizations, including the Alabama Invasive Plants Council, the Sidney B. Meadows Foundation of the Southern Nursery Association, and the Horticulture Research Institute. He was director of the Alabama Nursery and Landscape Association. Cotten coauthored the book *Easy Gardens for the South* in 2009, which is in its fourth printing. He travels all across the Southeast to talk about this instructional guide to creating and maintaining gorgeous horticulture. (Courtesy of Harvey Cotten.)

Mike Latty

For Mike Latty (b. 1955), a physical education teacher of 29 years at University Place Elementary School, his most important contribution is to make a positive impact on a child's life. "I want a kid to be a winner, not just to win games," he says. "When I coach, I'm teaching life."

It was his love of sports that led him to be a teacher. Latty grew up in Jamaica, where he lived until 1974, when he was recruited by Dr. Salah Yousif to play soccer at Federal City College, now the University of the District of Columbia. Dr. Yousif brought the soccer program to Alabama A&M and Latty along with it. They started their club in 1976, and A&M won the NCAA Division II national title in soccer in 1977. Latty graduated from A&M in 1979 with a degree in physical education.

In the 1980s, Latty began coaching at Grissom High School; many of his players still keep in touch with him, and some still play soccer. Latty left Grissom in the 1990s and returned to coach at A&M for one year; he has also worked with the A&M women's soccer coach. Now Latty coaches club teams for ages eight to eighteen. His focus is to make a team a complete unit. He notes that a sense of order is especially important for the little ones he teaches, who often have a lack of structure at home. "Soccer is not about an individual. It's about setting goals and following rules—[things] that apply in so many parts of life." (Courtesy of Mike Latty.)

Bobby Eaton

Professional wrestler Bobby Eaton (b. 1958) attended Lee High School in the late 1970s and went on to become a well-known tag team wrestler, perhaps most famously as part of the duo The Midnight Express in the 1980s. Along with wrestling partner Dennis Condrey, Eaton changed the composition of The Midnight Express from a group of wrestlers to an exclusively two-man team. It was during this time that he acquired the nickname "Beautiful Bobby."

Among a number of titles, Eaton is a three-time National Wrestling Association/World Championship Wrestling tag-team champion and a three-time NWA US tag-team champion. WCW issued a Beautiful Bobby Eaton action figure as part of its Team Wrestler Series in 1994. (Courtesy of Terrence Ward.)

Robert E. "Bud" Cramer Jr.
In 1985, while district attorney of Madison County, Bud Cramer (b. 1947) sought to create a better system for assisting abused children. He saw a rift between the social service and criminal justice systems in the way they handled such cases, noting that having children tell their story so many times to so many different people only served to add stress to an already incredibly distressing situation. Cramer's vision was to include and centralize the services of law enforcement, child protective services, medical and mental health professionals, and the criminal justice system. He founded the National Children's Advocacy Center (NCAC), which serves over 250,000 children each year. It has become a model for and has trained over 800 Children's Advocacy Centers nationally and 10 internationally. The NCAC in Huntsville has worked in an educational capacity with more than 54,000 professionals involved in handling cases of child abuse. In 1992, Cramer spearheaded the passage of the Victims of Child Abuse Act to provide funding for governmental and institutional support of Child Advocacy Centers.

Cramer earned his bachelor's and law degrees at the University of Alabama, served in the US Army Reserves, and was the district attorney of Madison County from 1981 to 1990. He served in the US Congress from 1991 to 2009. (Courtesy of the Huntsville–Madison County Public Library Archives.)

Jan Davis

When the first women were accepted to become astronauts in 1978, several of Jan Davis's colleagues at Marshall Space Flight Center suggested that she consider applying. Out of the 5,000 who applied for the class of 1985, only 128 were interviewed. Although Davis was not selected that year, she was accepted in 1987, one year after the *Challenger* accident.

Davis (b. 1953), who moved to Huntsville in the fifth grade, attended Randolph through ninth grade and graduated from Huntsville High School. Davis recalls what an exciting time it was to be in Huntsville with all the testing, and remembers going to the *Apollo 11* launch with her brother. Following high school, she received a bachelor's degree in applied biology from Georgia Institute of Technology (1975) and a degree in mechanical engineering from Auburn University (1977). She earned her master's and PhD degrees from UAH while working for NASA and attending night school. She had been working at Marshall Space Flight Center for several years following her graduation when she became an astronaut.

Davis moved to Houston for astronaut basic training with the full support of her family. During training, she learned shuttle systems, astronomy, and material sciences, among other disciplines. She served on three flights, in 1992, 1994, and 1997. Davis returned to Huntsville in 1999; in the time since, she has flown jets, made public appearances around the country and the world, including to school groups, and worked for NASA in an executive position until 2005. She now works for Jacobs Engineering as deputy general manager for contracts that support the space launch system. (Courtesy of the Huntsville–Madison County Public Library Archives.)

Julian Davidson

Aerospace executive Dr. Julian Davidson (1927–2013) founded Davidson Technologies in 1996; the company supplies engineering services to military contractors and to NASA. Davidson was deputy program manager of Ballistic Missile Defense for the US Army and was the first director of the Advanced Ballistic Missile Defense Agency. He also contributed to the system design of ballistic defense missiles, including interceptor missile design and radar design. The instrumentation he developed was used on the rocket that put the first US satellite into orbit.

In addition to his contributions to the aerospace industry both locally and nationally, Davidson and his wife, Dorothy, were devoted to advancing art, technology, and community, and donated funds to support the Davidson Center for the Arts at the Huntsville Museum of Art, which opened in 2010. The couple also contributed significantly to the US Space & Rocket Center, making possible the establishment of the Davidson Center for Space Exploration. The state-of-the-art building now houses a restored Saturn V rocket, one of three left in the world.

Among his many honors, Davidson was a member of the US Army Strategic Defense Employee Hall of Fame. (Photograph by the author.)

Loretta Purdy Spencer (OPPOSITE PAGE)
Prior to becoming Huntsville's first female mayor, Loretta Purdy Spencer (b. 1937), originally from Birmingham, was an elementary and middle school teacher who joined her father in the family's funeral-home business in the 1980s. Spencer joined the Huntsville Planning Commission in 1977, was on the Economic Development Board, and served on the Army Relations Board. While chairwoman of the planning commission, Spencer, along with Mayor Joe Davis and Joe Moquin of Brown Engineering, led the push to expand Cummings Research Park westward, eventually making it the second-largest technology park in the United States.

Spencer played an instrumental role in the founding of the Community Free Clinic and contributed considerably to the development of downtown Huntsville. During Spencer's three terms as mayor, the federal government approved two rounds of Base Closure and Realignment, luxury shopping complex Bridge Street Town Centre was opened, and Toyota Motor Manufacturing of Alabama opened a plant in Huntsville to produce V8 engines for the first time outside of Japan.

Always active in the community, Spencer served on the Von Braun Civic Center board for 20 years and has served on the symphony board. (Courtesy of the Huntsville–Madison County Public Library Archives.)

Gloria Batts (OPPOSITE PAGE)

Inspired by a television interview with educator Geoffrey Canada, Gloria Batts (b. 1950) joined with her friend Bobby Bradley in the late 1990s to address a national issue with local ramifications, reaching out to those in the community with the greatest needs, children in particular. Over the years, the two women attended a number of conferences in New York City about the Harlem Children's Zone, an organization that seeks to end childhood poverty through educational outreach. With their acquired knowledge, experience, and desire to end the cycle of poverty, Batts and Bradley founded the Village of Promise, which serves over 200 children in the Huntsville community.

A Huntsville native, Batts attended St. Joseph's School in West Huntsville. The school, which eventually became Holy Family School, was among the first elementary schools in Alabama to integrate. Batts graduated from Butler High School and went on to get her degree in sociology and history from Alabama A&M and a master's degree in biblical counseling from Whitesburg Biblical College. Her interest in human services and in faith-based organizations led her to work for the Alabama Department of Industrial Relations, specifically with the Job Training Partnership Act program in job development and placement for underserved communities. Batts also worked at the United Methodist Services Center and served the Butler Terrace community, among other housing developments in the city.

Through collaborations with local schools, hospitals, arts organizations, and others, the Village of Promise offers such innovative programs as a kindergarten tutoring program, a before-school Bible program, and a strings program in conjunction with the Huntsville Symphony Orchestra, which provides violin lessons for second graders at University Place School. Through the interactive six-week Freedom School program, children gain exposure to the field of biotechnology. Village of Promise stays with the children through the college admissions process, providing a counselor to help with scholarships and applications and with entering the workforce. (Courtesy of the Village of Promise.)

Liz Hurley
WAFF-TV news anchor Liz Hurley has twice been named Best News Anchor in the state by the Alabama Associated Press. She is a three-time Edward R. Murrow Award winner and a two-time Emmy nominee for her work in broadcasting, among her many other awards. In 1996, she reported for NBC during the summer Olympics in Atlanta.

In 1998, Hurley was diagnosed with breast cancer. She documented her experience, counseled others facing similar diagnoses, and, in 1999, established the Liz Hurley Breast Cancer Fund at the Huntsville Hospital Foundation in order to raise awareness and to facilitate funding for cutting-edge technology for hospitals in Huntsville and Madison. Each year, many thousands of people participate in the Liz Hurley Ribbon Run; the event raised over $335,000 in 2014. (Courtesy of WAFF.)

Jimmy Wales
Internet entrepreneur Jimmy Wales (b. 1966) founded Wikipedia in 2001, fulfilling his goal to create a content Internet resource and, subsequently, the world's largest encyclopedia. Wales attended Randolph School and went on to earn a finance degree from Auburn University and a master's degree from the University of Alabama. Additionally, he did coursework for a doctorate in finance at both the University of Alabama and Indiana University. He has an honorary doctorate degree from Knox College of Illinois. He and a colleague founded a for-profit web-hosting company, Wikia, in 2004. Wales serves on numerous advisory boards, became an official technology advisor to the British government in 2012, and has been named one of *Time* magazine's 100 most influential people. Wales is pictured here in 1983, standing fourth from left. (Courtesy of Randolph School Institutional Advancement Office.)

Margaret Hoelzer (BELOW AND OPPOSITE PAGE)
Margaret Hoelzer's approach to swimming in the Olympics is perhaps the key to her success: "When you go to the Olympics, it's just a swim meet." The two-time Olympian swam for the US team in Athens in 2004 and in Beijing in 2008. She is a three-time medal winner, capturing two silver and one bronze. Hoelzer (b. 1983) had an affinity for the pool from the age of three, when she began lessons. By age seven, she was swimming year-round. After she graduated from Huntsville High School in 2001, she attended Auburn University, where she earned a degree in psychology with a minor in criminology. She made the Olympic swim team in 2004. An agent approached her shortly after, and she signed with Speedo in May 2005, the same year she graduated college. After living in Charlotte, Seattle, and Fullerton, California, Hoelzer returned to Seattle, where she now resides. Retired from swimming, she devotes her time to speaking publicly about child sexual-abuse prevention. Her mission is to raise awareness about the problem and to educate the public on the topic, specifically on prevention efforts. Hoelzer, who speaks openly about her own experience as a survivor of child sexual abuse, stresses the importance of children getting help and of not letting such an experience be the end of one's life.

In 2007, Hoelzer reached out to the National Children's Advocacy Center in Huntsville, from which she received services as a child. The NCAC, founded in 1985 by former congressman Bud Cramer, was the first center of its kind in the United States. Hoelzer is the NCAC's national spokesperson. (Courtesy of Martha Hoelzer and A Breath of Fresh Air Photography.)

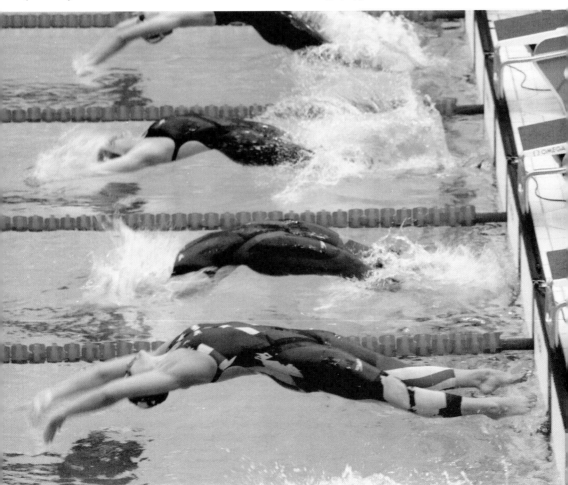

David Harwell (OPPOSITE PAGE)

A native of Huntsville, David Harwell's talent in and passion for theater have taken him up the East Coast and back in roles of set design, production, and directing. Harwell graduated from Grissom High School and attended the University in Montevallo, where he earned his bachelor's degree in acting and directing in 1987. In 1991, he earned his master's degree in scene design from the University of Illinois at the Krannert Center, after which he moved to Boston, where he worked for the Huntington Theatre Company, the Boston Lyric Opera, and the New England Conservatory of Music. He relocated to New York City, where he worked for the Roundabout Theatre Company and Playwrights Horizons, along with various regional companies from Denver to Pittsburgh. In 1998, he began working as a designer with Production Design Group in New York, a company that provided scenery for NBC, Turner Sports, A&E, MSNBC, MTV, and other media outlets; during this time, he received a daytime Emmy award for his design work for *Between the Lions*, a PBS children's show filmed in New York City.

Harwell returned to Huntsville in 2002 and was hired in 2005 by the University of Alabama in Huntsville to begin and direct a theater program. The ambitious program now produces four main stage shows each year. Because of Harwell's tireless and committed efforts, the university will begin to offer a bachelor's degree in theater in the 2015 academic year. Now a full-time assistant professor, Harwell and the theater department have collaborated in the past with other arts organizations in Huntsville, including the Huntsville Ballet Company. In 2014, Harwell designed the set for the ballet's annual holiday production of *The Nutcracker*. (Courtesy of David Harwell.)

Susanna Phillips (ABOVE AND OPPOSITE PAGE)

World-renowned soprano opera singer Susanna Phillips did not initially set out to sing. When she began exploring colleges as a student at Randolph School, she was intent on becoming a doctor. She loved math and science and had played sports, been a member of the French club, and was an honors student. She also sang in the school choir, and her guidance counselor suggested she apply to conservatory just to have it as an option.

Phillips was accepted into the Julliard School in New York City, where she graduated with two degrees in 2003 and 2004. In 2005, her career took off, and she won four national vocal competitions: Operalia, Metropolitan Opera National Council Auditions, MacAlister Awards, and George London Foundation. December 2008 found her, along with 500 supporters from her native Huntsville, debuting in *La Bohème* at the Metropolitan Opera in New York City. The performance is pictured opposite.

Phillips has reciprocated the unending support of her hometown, cofounding Twickenham Fest in 2010, with the mission of bringing exceptional classical music to Huntsville. This summer chamber music festival takes classical music master classes and performances into schools, universities, libraries, and other educational initiatives for a full week in August. When the festival began, there were 15 attendees at two concerts; by 2014, all five concerts were sold out. At the Village of Promise, the program reached over 750 children.

Among her many operatic roles are Rosalinde in *Die Fledermaus*, Stella in *A Streetcar Named Desire*, Ellen Orford in *Peter Grimes*, Musetta in *La Bohème*, and Donna Anna in *Don Giovanni*. She has traveled to Japan, Mexico, Chicago, and New Orleans, and is sought after by prestigious symphonies around the globe.

Her family has strong ties to the Huntsville community and is very involved in and supportive of it. Additionally, because she has never lived in any one place for more than 180 days, the time required to become a resident, Susanna remains a resident of Alabama. (Both, courtesy of Susanna Phillips; above, photograph by Zachary Maxwell Stertz.)

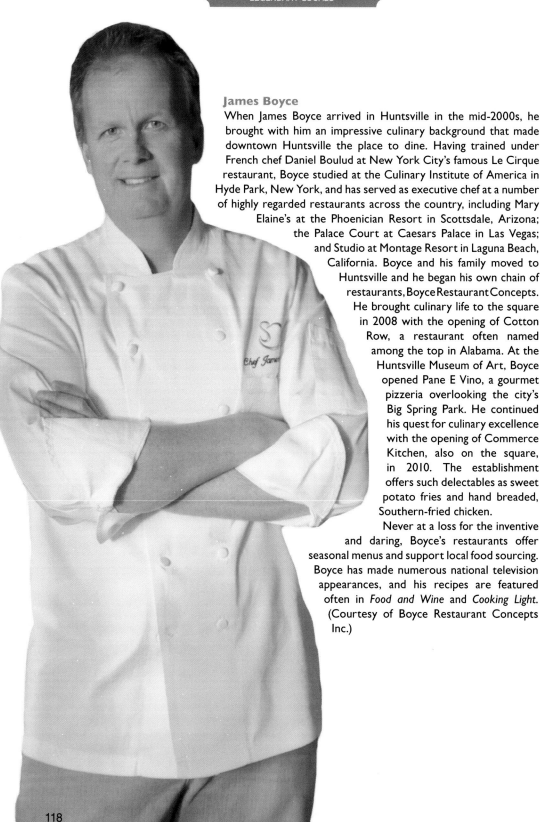

James Boyce

When James Boyce arrived in Huntsville in the mid-2000s, he brought with him an impressive culinary background that made downtown Huntsville the place to dine. Having trained under French chef Daniel Boulud at New York City's famous Le Cirque restaurant, Boyce studied at the Culinary Institute of America in Hyde Park, New York, and has served as executive chef at a number of highly regarded restaurants across the country, including Mary Elaine's at the Phoenician Resort in Scottsdale, Arizona; the Palace Court at Caesars Palace in Las Vegas; and Studio at Montage Resort in Laguna Beach, California. Boyce and his family moved to Huntsville and he began his own chain of restaurants, Boyce Restaurant Concepts. He brought culinary life to the square in 2008 with the opening of Cotton Row, a restaurant often named among the top in Alabama. At the Huntsville Museum of Art, Boyce opened Pane E Vino, a gourmet pizzeria overlooking the city's Big Spring Park. He continued his quest for culinary excellence with the opening of Commerce Kitchen, also on the square, in 2010. The establishment offers such delectables as sweet potato fries and hand breaded, Southern-fried chicken.

Never at a loss for the inventive and daring, Boyce's restaurants offer seasonal menus and support local food sourcing. Boyce has made numerous national television appearances, and his recipes are featured often in Food and Wine and Cooking Light. (Courtesy of Boyce Restaurant Concepts Inc.)

Robert Kennedy

Kennedy's introduction to Google came in 1999, when several of his colleagues suggested he apply to work there. He chose instead to go to another, more established company with a tangible product, but, seven years later, Kennedy began working at Google on the production side of the search engine.

A 1983 graduate of Randolph School, Kennedy (b. 1966) attended Vanderbilt University, where he earned degrees in mathematics, computer science, and electrical engineering. He obtained his PhD in computer science from Stanford University.

Kennedy, an avid musician who plays piano and jazz organ, performs in the San Francisco area in the Robert Kennedy Trio. As a software engineer for Google, he currently works on cluster management infrastructures, a system that decides what every machine in the data center is doing at any given time; he then assigns distributive operative resources to what needs to be done and assesses what will be running on a given machine. In addition to his part in improving the general public's access to information through his work at Google, Kennedy is proud to have worked on the rectification of President Obama's healthcare.gov website after the failure of the initial rollout. (Courtesy of Robert Kennedy; photograph by L.A. Cicero.)

Thomas "Tommy" Battle Jr. (OPPOSITE PAGE)
Under the leadership of Mayor Tommy Battle (b. 1955), the City of Huntsville continues to be named in national publications as one of the top places to live, work, and raise a family. With a focus on an educated workforce, infrastructure, and a high quality of life, Huntsville attracts young professionals while retaining many of those who grew up here. Mayor Battle's consistent focus is on leaving behind something that can continue to move forward.

Born in Birmingham, Alabama, in 1955, Battle moved to Huntsville in his early twenties to manage Britling's Buffet. From that experience, he learned all aspects of running a business, including managing revenue and expenditures. He served on the Huntsville City Council from 1984 to 1988 as the finance chair and ran for mayor in 1988. Though defeated in that race, Battle continued his commitment to improving the city of Huntsville. He ran again, and won the mayoral race in 2008 and is now serving his second term.

Among his many accomplishments as mayor are $383 million worth of road improvements and four urban developments in downtown Huntsville. In 2014, Remington Outdoor Co. committed to bring a production plant and many jobs to Huntsville. In addition, under Battle's tenure, there has been a resurgence in public education. (Courtesy of Huntsville City Office of the Mayor.)

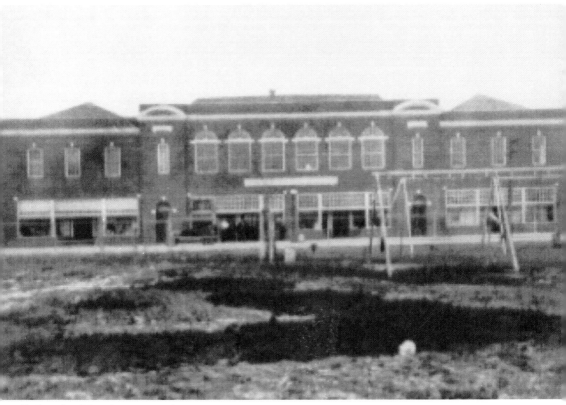

Debra Jenkins (OPPOSITE PAGE)
When Debra Jenkins (b. 1960) and her husband, Alan, looked at Merrimack Hall (above) as a potential arts center, they saw much more than just the possibility for a dance studio. Formerly the cultural center of Merrimack Village in West Huntsville, Merrimack Hall had originally housed two mercantile stores, a café, a gym, a library, an auditorium, and a barbershop. It was central to the life of the village of Merrimack Mill, a textile mill. At one point, it had its own newspaper, *The Merrimacker*, later called the *Huntsville Parker*. In the 1950s, Lowenstein & Company bought Merrimack Mills and opened Huntsville–Manufacturing Company. In 1992, the mill buildings were demolished, leaving only the houses and a very dilapidated and forgotten Merrimack Hall as evidence of the former hustle and bustle of the community.

In 2007, Jenkins, a former dancer, dance instructor, and active community volunteer and supporter of the arts in Huntsville, and her husband opened Merrimack Hall Performing Arts Center, a nonprofit, 3,000-square-foot dance studio and 300-seat, state-of-the-art theater with a mission of community outreach, top-notch performance, and educational and performance opportunities for children and teens with special needs through the Johnny Stallings Art Program. Merrimack won the 2007 Neighborhood Revitalization award from the Huntsville Historic Society. Merrimack's programs serve over 500 children in the community.

Jenkins, who has served on a number of community boards, volunteered in the capacity of executive director of Merrimack until 2012 and now serves as chair of its advisory board. She is the recipient of the Virginia Hamill Simms award for individual outstanding contribution to the arts, received *Traditional Home* magazine's Classic Woman Award in 2009, and spoke recently of her experience and commitment to Merrimack at the TEDxHuntsville 2014 conference. Jenkins writes a regular blog, "Dreaming with Your Feet." (Opposite, courtesy of Debra Jenkins, photograph by K8Photo; above, courtesy of the Huntsville–Madison County Public Library Archives.)

Margaret Anne Goldsmith

(RIGHT AND OPPOSITE PAGE)
After a number of years in New Orleans, where she attended Tulane University and raised her three children, Margaret Anne Goldsmith (b. 1941) returned to her hometown of Huntsville in 1995. She became the president of I. Schiffman & Company that same year, taking on the responsibility of its many property holdings and other matters of the century-old family business. Throughout the years, she has made it her life's work as a preservationist and historian to convert her family's farmland into both residential and commercial developments, while preserving and promoting the history of the Jewish community in Huntsville.

Along with her three children, Goldsmith donated 300 acres of wetlands and forest to the city in 2003 to start a wildlife preserve in the Big Cove community. In 2009, together with artist Clayton Bass, then CEO of the Huntsville Museum of Art, Goldsmith conceived of the Sanctuary Artists, a group of painters, poets, sculptors, and the like whose work focuses on the sanctuary as its subject for its medium. Additionally, Goldsmith and her children donated land to the city for the construction of the Goldsmith Schiffman Elementary School, a public school located within walking distance of the Goldsmith Schiffman Wildlife Sanctuary.

Goldsmith has served on numerous civic boards in the Huntsville community, including the Huntsville Madison County Community Foundation. She has written numerous articles and stories about the legacy of her family and has donated countless family artifacts to museums of Jewish history across the country. She is pictured at right in the Big Spring. (Opposite, courtesy of Margaret Anne Goldsmith; right, courtesy of the Huntsville–Madison County Public Library Archives.)

Wade Wharton

After suffering from a stroke in 1974, Huntsville resident Wade Wharton (1937–2014) declared that the left side of his brain was virtually gone and that the stroke had changed his mind and opened up his creative side. He retired from his job and began experimenting in a number of different art forms, including painting, drawing, stained glass, poetry, gardening, and whittling. Eventually, he came to use metal and other castoffs to create sculpture, an art form for which the city fined him in 2008, calling his sculptures "junk."

Wharton, an active volunteer at the Huntsville Botanical Gardens, helped establish the Fern Glade there and was once named Volunteer of the Year at the botanical gardens. He was a member of the gourd society and the wildflower society. The Wade Wharton Sculpture Trail opened at the garden in March 2013 in celebration of the garden's 25th anniversary. (Courtesy of Huntsville Botanical Garden.)

INDEX

Able, 63
Baldridge, Felix, 29
Bankhead, Tallulah, 50
Bass, Clayton, 125
Battle, Thomas, 120, 121
Batts, Gloria, 69, 108, 109
Bibb, Thomas, 13
Bibb, William Wyatt, 9, 14
Bohlen, Charles, 51
Boyce, James, 118
Bradley, Bobby, 69, 108
Bradley, Joseph Sr., 44
Burritt, William Henry, 48, 49
Butler, S.R., 35
Carter, Jimmy, 95
Carter, Sally, 20
Cashin, John, 67, 96
Cashin, Sheryll, 96
Caylor, Mary Jane, 93
Chadick, Mary Jane, 9, 21
Christian, Mike, 86
Clay, Clement Comer, 9, 15, 16
Clay-Clopton, Virginia Tunstall, 18, 19
Clopton, Anne Bradshaw, 31, 38
Condrey, Dennis, 102
Cotten, Harvey, 100
Councill, William Hooper, 9, 22, 37
Cramer, Robert E. "Bud," 69, 103, 113
Davidson, Julian, 69, 105
Davis, Jan, 104
Davis, Joe, 52, 75, 90, 107
DeBerry, Dulcina, 31, 42
Drake, J.F., 31, 40
Dunnavant, P.S., 31, 36
Eaton, Bobby, 102
Eggbeater Jesus, 87
Erskine, Albert Russel, 36, 41
Fearn, Dr. Thomas, 9, 12, 16
Fisk, Sarah Huff, 53
Fris, Erik, 75, 76
Garth, William Willis, 28
Gay, Dr. Otis, 52
Goldsmith, Betty Bernstein, 26
Goldsmith, Lawrence B. Jr., 30
Goldsmith, Margaret Anne, 124, 125
Goldsmith, Lawrence B. Sr., 30, 47

Grosser, Maurice, 39
Halsey, William L. III, 59
Handy, W.C., 37
Harris, Bartley, 21
Harris, Chessie, 56, 57
Harris, Ron, 75, 97
Harris, William, 21
Harrison, Daniel, 9, 28
Harrison, John, 28
Harrison, Robert, 9, 28
Harwell, David, 114, 115
Hays, J.D., 72
Hearn, Glenn, 75
Hereford IV, Sonnie, 67
Hereford, Dr. Sonnie Wellington III, 45, 67
Herriott, Helen Moore, 70, 74, 81
Hoelzer, Helmut, 50
Hoelzer, Margaret, 112, 113
Holbrook, Bill, 94
Hudson, Jim, 32, 69, 70, 88, 98, 99
Hunt, John, 7, 10, 11
Hunt, R.H., 36
Hurley, Liz, 110
Jenkins, Alan, 32, 69, 70, 123
Jenkins, Debra, 32, 69, 70, 75, 122, 123
Jones, A.B., 9, 17
Jones, Harvie, 60, 69, 75, 84, 85
Jones, John Rison Jr., 43
Jones, Raymond B., 77
Judd, S.W., 34
Kabalevsky, Dmitri, 81
Keller, Helen, 29
Kennedy, Robert, 119
King, Olin, 69, 73
Latty, Mike, 101
Lee, Robert E., 21, 28
Lily Flagg, 9, 27
Longstreet, James, 28
Lowe, Jane Knight, 78, 79
Lowery, Joseph, 45, 68
McCain, John, 86
McCarthy, Joseph, 51
McCormick, Cyrus, 29, 34
McCormick, Mary Virginia, 29, 34
McHugh, Doris, 95

McLain, D. Scott, 91
McLain, Gene, 88, 91
McMillian, Lonnie, 82, 99
Merrill, Eunice, 71
Mincher, Don, 83
Miss Baker, 63
Mitchell, Ed, 66
Moquin, Joe, 107
O'Shaugnessy, James, 29
O'Shaugnessy, Michael, 29, 34
Phillips, Susanna, 116, 117
Pierce, Jacob Emory, 36
Pope, Leroy, 10, 11, 12, 16
Pratt, Tracy, 33
Record, James, 13, 64, 65
Rhett, Harry Jr., 58
Rhett, Harry Sr., 58
Roberts, Frances Cabannis, 60, 61
Schiffman, Annie, 47
Schiffman, Isaac, 9, 30, 47
Schiffman, Robert, 30
Schiffman, Solomon, 30
Simms, Virginia Hammill, 75
Simpson, Fred, 92
Smith, Mark, 69, 82
Sparkman, John, 51
Spencer, Loretta, 75, 106, 107
Stallworth, John, 89
Steele, George Gilliam, 2, 9, 10, 12, 17
Stein, Gertrude, 39
Stuhlinger, Ernst, 62
Teal, Mollie, 26
Thompson, Virgil, 39
Toklas, Alice, 39
Townes, Harry, 80
Tygett, Loyd, 70, 74, 81
Vanderbilt, William, 29
von Braun, Wernher, 45, 46, 51, 54, 55, 62, 82
Wales, Jimmy, 111
Walker, Grace, 34
Walker, Leroy Pope, 23
Weeden, Maria Howard, 9, 24, 25, 53
Westmoreland, Dr. Hawkins D., 29
Wharton, Wade, 126

AN IMPRINT OF ARCADIA PUBLISHING

Find more books like this at
www.legendarylocals.com

Discover more local and regional history books at
www.arcadiapublishing.com